KT-178-217

LRC Stoke Park
GUILDFORD COLLEGE

The Fundamentals
of Digital Art

WITHDRAWN

ava | Academia
the environment of learning

186315
776 COL

An AVA Book
Published by AVA Publishing SA
Rue des Fontenailles 16
Case Postale
1000 Lausanne 6
Switzerland
Tel: +41 786 005 109
Email: enquiries@avabooks.ch

Distributed by Thames & Hudson (ex-North America)
181a High Holborn
London WC1V 7QX
United Kingdom
Tel: +44 20 7845 5000
Fax: +44 20 7845 5055
Email: sales@thameshudson.co.uk
www.thamesandhudson.com

Distributed in the USA & Canada by:
Watson-Guptill Publications
770 Broadway
New York, New York 10003
USA
Fax: +1-646-654-5487
Email: info@watsonguptill.com
www.watsonguptill.com

English Language Support Office
AVA Publishing (UK) Ltd.
Tel: +44 1903 204 455
Email: enquiries@avabooks.co.uk

Copyright © AVA Publishing SA 2007

All rights reserved. No part of this publication may be
reproduced, stored in a retrieval system or transmitted
in any form or by any means, electronic, mechanical,
photocopying, recording or otherwise, without
permission of the copyright holder.

ISBN 2-940373-58-2 and 978-2-940373-58-1

10 9 8 7 6 5 4 3 2 1

Design by Simon Slater, www.laki139.com
Cover image courtesy of Jim Campbell

Production by AVA Book Production
Pte. Ltd., Singapore
Tel: +65 6334 8173
Fax: +65 6259 9830
Email: production@avabooks.com.sg

The Fundamentals of Digital Art

Richard Colson

Table of contents

Introduction

The fundamentals of digital art

This book explores six major themes in digital art: its history, using responses, data, coding, networking and digital hybrids. These areas have been formulated on the basis of a study of the working methods and practice of individual artists, from both the past and present. When looking at an artist's work, it is sometimes difficult to see where it fits within a broader scheme, but the aim of this book is to provide some basic tools to allow you to do this.

These six themes will draw out the key practices and debates that govern the present forms of digital art. For example, some artists want to give the computer almost full control of their final piece whereas others prefer a more limited or partial contribution from the technology. In a way, you might like to think of each of these themes in digital art as individual islands within an archipelago. Each island has its own idiosyncrasies, but still maintains a place within the larger land system.

Major developments in digital art have often come as a result of cooperation between artists. In the same way that climbers have to tackle a sheer rock face as a team roped together, individual artists have been generous with their knowledge and created networks built around their own special interest. They have found that this does in fact work to their advantage because other artists use these discoveries as a basis for their own work and research and in doing so reach their own unexpected outcomes, which in turn are made available to all the other members of the group. 'The Fundamentals of Digital Art' will follow in this same pattern, and whilst providing essential information it will also create the necessary channels to allow for feedback and further discussion.

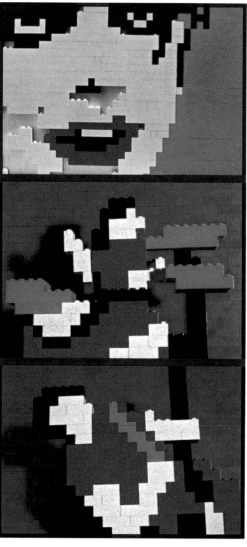

←
Video stills from White Stripes' 'Fell in Love With a Girl'
Michel Gondry, 2002
Licensed courtesy of XL Recordings Ltd
www.xlrecordings.com
A compelling example of the digitised world. A visual tension occurs as the complexity of vision is sought within a world created with coloured building blocks.

→
Random Formations
Richard Colson, 2003
These images were created with object-oriented programming in Flash ActionScript. Unlimited variations are generated as the program is allowed to decide the properties of each element.

↓
DrawBots
Paul Brown, 2005–2008
This research project, based at the University of Sussex, examines whether it is possible to create a drawing machine that learns and develops its own style.

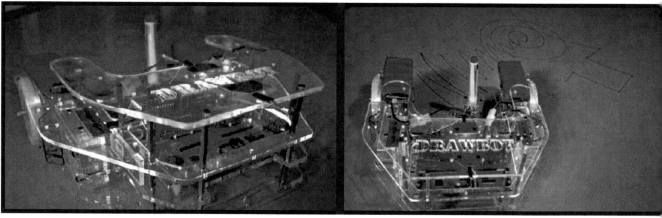

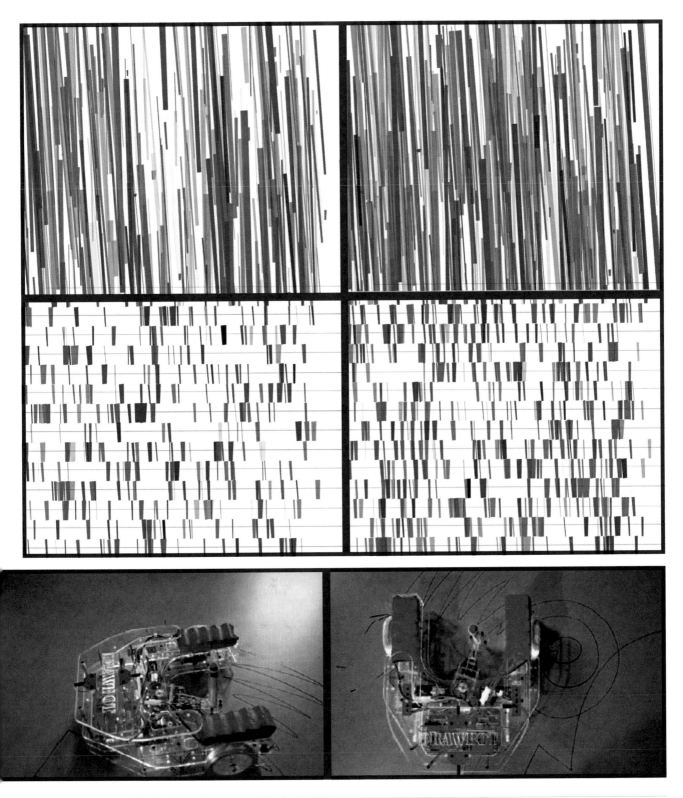

How to get the most out of this book

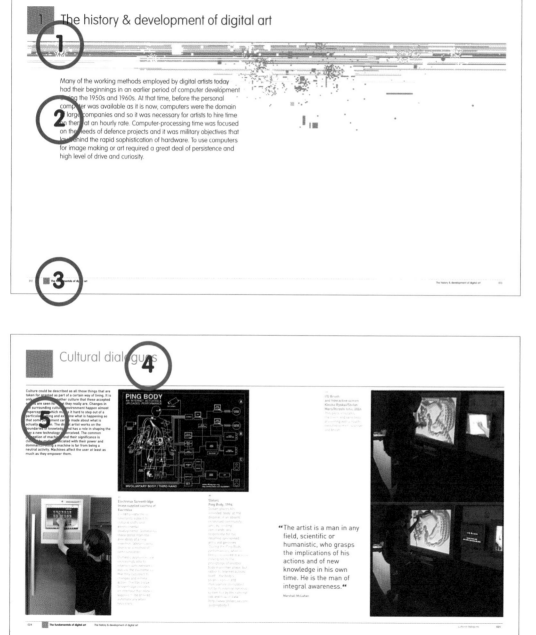

1 The history & development of digital art

Many of the working methods employed by digital artists today had their beginnings in an earlier period of computer development during the 1950s and 1960s. At that time, before the personal computer was available as it is now, computers were the domain of large companies and so it was necessary for artists to hire time on them at an hourly rate. Computer-processing time was focused on the needs of defence projects and it was military objectives that lay behind the rapid sophistication of hardware. To use computers for image making or art required a great deal of persistence and high level of drive and curiosity.

1 Chapter opening titles
Highlight each of the six key areas under discussion.

2 Chapter introductions
Outline the purpose of the chapter.

3 Navigation
Helps you to move through the book by highlighting the chapter and chapter-unit titles.

4 Chapter-unit titles
Signify a new section within the chapter.

5 Chapter-unit introductions
Outline what each chapter-unit will explore.

6 Linked picture boxes
Related imagery is contained within linked picture boxes to highlight the relationship between the pictures.

7 Text
Provides in-depth discussion of working methods, best practice and issues and debates. Key terms, artists or technologies are underlined and more information about these can be found in the knowledge bank for the chapter unit.

8 Picture captions
Provide insight and contextual information about each of the graphic examples.

9 Box outs
Provide helpful supplementary information.

10 Quotes
Insightful and inspirational commentary from respected authorities.

11 Knowledge banks
Provide further sources of information for the key terms, artists and technologies highlighted in the main body copy.

1 The history & development of digital

Many of the working methods employed by digital artists today had their beginnings in an earlier period of computer development during the 1950s and 1960s. At that time, before the personal computer was available as it is now, computers were the domain of large companies and so it was necessary for artists to hire time on them at an hourly rate. Computer-processing time was focused on the needs of defence projects and it was military objectives that lay behind the rapid sophistication of hardware. To use computers for image making or art required a great deal of persistence and high level of drive and curiosity.

art

A timeline of digital art

1950
'Cybernetics and Society' by Norbert Weiner is published (MIT Press). The book is a key study of human relationships with machines, covering both communication and control systems.

1951
A graphics display is shown on a vectorscope connected to a Whirlwind computer (developed at MIT) in the first public demonstration of such a device. From now on the interface with a computer would begin to provide the immediate response that is expected from a PC today.

↑
1956
Ray Dolby, Charles Ginsburg and Charles Anderson of Ampex develop the Mark IV, it is the first videotape recorder and the price tag is $50,000.

1958
John Whitney Sr uses analogue computer equipment to make animated film sequences.

1960
William Fetter of Boeing coins the term 'computer graphics' for his human factors cockpit drawings.

↑
1961
'Spacewars' is developed by Steve Russell (at MIT) for the DIGITAL EQUIPMENT CORPORATION's PDP-1 computer. It is the world's first video game.

1962
The computer mouse is invented by Doug Englebart of Stanford Research Institute (SRI).

The first computer-generated film is produced by Edward Zajac, a physicist at Bell Labs. The film showed that it was possible to reorient a satellite so that it always faced the earth as it pursued its path of orbit.

↑
1963
William Fetter of Boeing creates the 'First Man' digital human for cockpit studies.

Charles Csuri makes his first computer-generated artwork. He was based in the mathematics department at Ohio State University.

↑
1964
New York World's Fair is held. This is a showcase for American corporate confidence and celebrated the future benefits that were to be expected from technological discoveries.

↓
1965
The first computer art exhibition is held at Technische Hochschule in Stuttgart. This included work by Frieder Nake (below), Michael Noll and George Nees.

The first US computer art exhibition is held at the Howard Wise Gallery in New York.

1966
'Odyssey' is developed by Ralph Baer of Sanders Associates Inc. Baer is the first person to propose the use of a domestic TV set for playing computer games and Odyssey was the first commercial computer graphics product.

Studies in Perception I by Ken Knowlton and Leon Harmon (Bell Labs) – one of the most compelling examples of an image constructed from the alphanumeric characters of an ASCII printer.

1967
Experiments in Art and Technology (EAT) is founded in New York by artists Robert Rauschenberg and Robert Whitman together with the engineers Billy Kluver and Fred Waldhauer. EAT aimed to forge effective collaborations between artists and engineers.

Sony's TCV-2010 videotape recorder is launched. This was a ½-inch open reel videotape recorder that now brought video recording within the reach of the home market.

1968
Cybernetic Serendipity: The Computer and the Arts exhibition is held at the London Institute of Contemporary Arts.

The Computer Arts Society is formed (as a branch of the British Computer Society), by John Lansdown (architect) and Alan Sutcliffe (pioneer of computer music).

1969
First use of computer graphics for commercial purposes (MAGI for IBM).

SIGGRAPH (Special Interest Group for Computer GRAPHics) is formed.

Event One is organised by the Computer Arts Society and held in London.

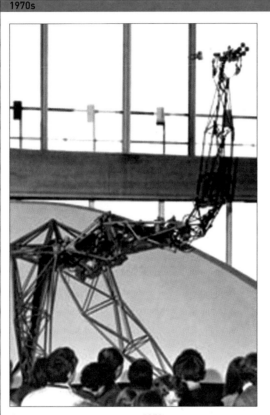

↑
1970
Edward Ihnatowicz's 'Senster' is installed at Philips' Evoluon Building in Eindhoven, the Netherlands.

1971
The world's first museum-based solo exhibition of computer generated art by Manfred Mohr is held at the Musée d'Art Moderne in Paris.

1972
Atari is founded by Nolan Bushnell.

↓
The 'Pong' video game is developed for Atari.

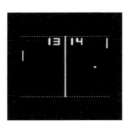

1973
Moore's Law, which states that the number of transistors on a microchip will double every 18 months, is coined by Intel's chairman, Gordon Moore.

The first SIGGRAPH conference is held in Boulder, Colorado.

'Principles of Interactive Computer Graphics', by William M Newman and Robert F Sproull, the first comprehensive graphics textbook, is published.

1975
Benoit B Mandelbrot (IBM Fellow at the Watson Research Center) develops fractal geometry and publishes 'Les objets fractals, forme, hasard et dimension'.

Bill Gates founds Microsoft.

↓
Martin Newell develops the computer graphics teapot in 3D at University of Utah. (The physical teapot is now in the Computer History Museum in Boston.)

1976
Steve Jobs and Steve Wozniak start Apple computer. The Apple I is launched by Steve Wozniak.

'Artist and Computer' by Ruth Leavitt is published.

↑
1977
Apple II is released.

1979
The first Ars Electronica conference is held in Linz (Austria). This conference and festival is now in its 25th year.

A timeline of digital art

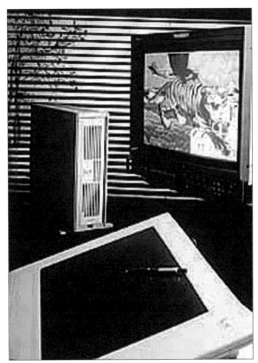

1986
Softimage is founded by Daniel Langlois in Montreal. This company pioneered software that delivered real-time 3D rendering.

The BBC produces 'Painting with Light'. In the programme, artists such as David Hockney, Howard Hodgkin, Richard Hamilton, Sir Sidney Nolan, and Larry Rivers are invited to use the Quantel Paintbox.

Andy Warhol uses Amiga to produce a self-portrait and portrait of singer Debbie Harry.

↓
1988
Art and Computers exhibition is held at the Cleveland Gallery, in Middlesborough (UK).

↑
1989
Adobe releases its paint software Photoshop.

↑
1990
Microsoft ships its Windows 3.0 operating system.

1991
Sir Tim Berners-Lee develops the World Wide Web at CERN (European Organisation for Nuclear Research).

Jeffrey Shaw's 'The Legible City' is exhibited at ZKM (Center for Art and Media, Karlsruhe).

1992
QuickTime is introduced by Apple Computer.

The first New York Digital Salon (US) is opened. In conjunction with the MIT publication Leonardo, this provides an annual showcase for artists exploring the possibilities of digital technology.

1980
The MIT Media Lab is founded by Nicholas Negroponte.

↑
The UK-based company Quantel introduces its Paintbox.

1981
IBM introduces the first IBM PC (16 bit 8088 chip).

1982
Jim Clark founds Silicon Graphics Inc.

Sun (Stanford University Network) Microsystems is founded.

1983
The SGI IRIS 1000 graphics workstation is launched.

Harold Cohen exhibits work produced with his AARON computer program at London's Tate Gallery.

1984
The first Macintosh computer is sold.

'Soft Computing' by Brian Reffin Smith is published.

1985
Commodore launches the new Amiga.

1993
GPS (Global Positioning System) is launched. This is operated and maintained by the US Department of Defense and uses the combined facility of 24 satellites.

'Wired' magazine launches in the US.

The computer game Doom is released. This pioneered the use of 3D graphics within a game context.

NETSCAPE

Myst is released by Cyan Worlds Inc. It becomes the top-selling game of all time.

↑
1994
Netscape browser is made available.

↓
1995
'Toy Story' (Pixar) is released. 3D computer graphics are used to enhance character and narrative within a mainstream film and not only for special effects.

Internet Explorer 2.0 is launched.

Sony's Playstation is introduced.

Sun introduces its Java programming environment.

1996 ID Software's 'Quake' hits the game market.

Macromedia buys FutureSplash Animator from FutureWave Technologies. It will later become Flash.
Steve Dietz becomes Curator of New Media at the Walker Art Center in Minneapolis MS.

Peter Weibel becomes director of ZKM (Center for Art and Media) in Karlsruhe, Germany.

↑
'Being Digital' by Nicholas Negroponte (founder of the MIT Lab) is published.

↑
Rhizome.org is founded in the US. This is a not-for-profit affiliation of artists using computer technologies in their work. It provides a database and catalogue of work from across the world.

1997
Flash 1.0 is released by Macromedia

↓
The Serious Games exhibition is held at the Barbican Art Gallery in London.

1998
Alias releases Maya 3D software for modelling and animation.

2000
↑
The 010101 Art in Technological Times exhibition is held at the San Francisco Museum of Modern Art.

Sony's Playstation 2 is launched.

2001
Microsoft's Xbox and Nintendo's GameCube games consoles are released.

'BitStreams' exhibition is held at the Whitney Museum of American Art in New York.

Art and Money Online exhibition is held at the Tate Britain in London.

2003
Alias/Wavefront becomes Alias.

2005
Adobe purchases Macromedia for US $3.4billion.

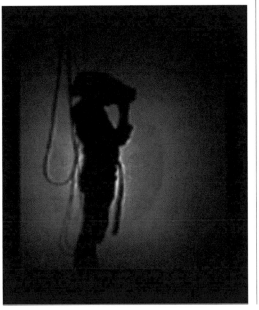

Dynamic exchanges

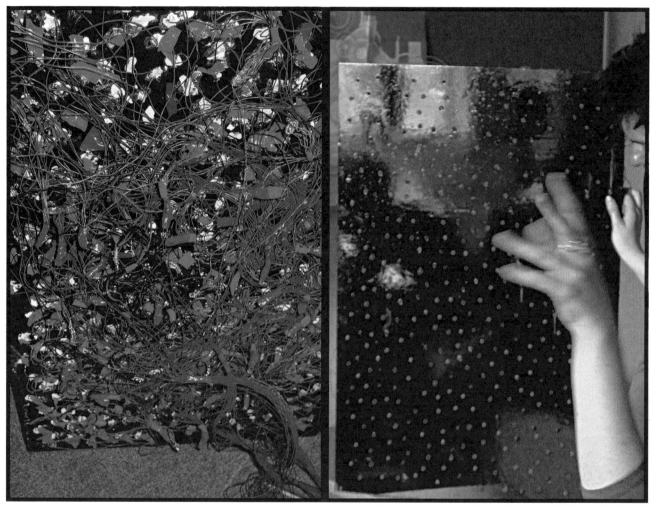

↑
**LED Wiring for Games
Console Project.
Second Year BA Digital
Arts Students, Thames
Valley University, 2006**
As the user interacts
with the games console
a parallel life of random
patterns lights up a
board of LEDs.

The fundamentals of digital art The history & development of digital art

The digital artist usually has to collaborate as part of their working process and this means that their practice will involve a high level of negotiation and an ability to work within a framework that is sometimes determined by others.

Practice in a technologically complex environment

There are a number of responses for the artist as they are confronted by the complexity of possibilities presented by the Internet, powerful software and the availability of interactive technology. The first (and most obvious) is to pretend that the potential is simply not there, and that their working practice can go forward without reference to these advances, cocooned in a technology-free vacuum.

The second response might be a partial acceptance that things are changing, and that some contact with technology may be necessary. Perhaps not as the main focus of their work, but certainly as a factor in its dissemination or presentation to the public.

The third response is characterised by an intense curiosity and a complete acceptance of the radical ways in which technology can alter and energise the working process, the goals and the whole aesthetic context in which work is made.

Most artists can identify with each of these responses and have probably found themselves falling in line with one or other of them at different points in their career.

Perhaps the main reason why many artists seek refuge in the first very defensive position derives from their sense that they cannot see how to retain their own individual approach when faced with the power of technology. Brian Reffin Smith was highly influential during his tenure at the Design Research Department at the Royal College of Art in London in the 1980s. He described the problem of much contemporary digital art as being 'where the state of the art technology so often equals state of the technology art'. Artists often need to work through an idea over a period of time, and the speed of technological innovation may not allow for these important periods of reflection.

↑
The Artist in
a Wired Studio
Richard Colson, 1983
This image has the feel
of a character from a
Rembrandt etching who
is given the chance to use
electronic drawing tools.
How will the artist
respond to these new
possibilities?

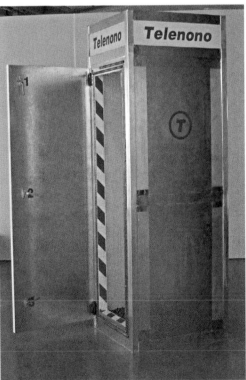

←
Telenono
(Wireless Phone Booth)
Rupert Griffiths, 2004
Image courtesy of the artist
On entering the phone
booth, the visitor was
completely cut off from all
radio signals, wireless
networks, sights and
sounds and could pursue
their own thoughts
without interruption.
Exhibited as part of the
Futuresonic 2004
exhibition.

FER
NUCLEUS

↑
Stills from Digital Hustle (above) and Hybrid Fusion (far right) Susumu Asano, 2006 This video narrative tackles urban claustrophobia and the pace of contemporary lifestyles. Here a combination of arbitrary data sources provides the artist with a new opportunity for expression. A reflection of a multi-layered information environment.

Finding effective working processes with technology

Artists are inquisitive about their own creativity. They are also used to reflecting on the potential outcomes of forms of expression that they are unfamiliar with, and are constantly making discoveries that make connections between their idea and the mode of expression they have elected to work with. Sometimes, it is hard to see whether it was the artist's idea that demanded the use of a particular medium, or whether the time spent becoming familiar with it gave rise to fresh artistic outcomes.

Perhaps it is dangerous to become too analytical about processes that are very often so intertwined and interdependent. The key thing to understand here is that artists need to reach a point where their work finds a form that resolves these discussions satisfactorily and operates within the context of their own creative direction. This then allows them to move on and make further work that builds on what they have learned and develop a practice in the same direction (or decide to change course completely).

Artists are fascinated by technical developments that suddenly give them access to a whole new tract of creative territory. Of course, they need to discover the rules of engagement and the procedural method that will open this up for them, but they are not averse to this process of familiarisation and the accompanying level of commitment that is often required. The sense that they are working across boundaries that may not have been crossed in the same way before, fuels what is almost a pioneering spirit. This will often mean that they will need to solve problems that crop up in the process without a great deal of assistance, simply because the expertise to do so may not yet exist in sufficient strength.

KB Knowledge Bank

1. Brian Reffin Smith (p.19) was tutor at the Royal College of Art, London in the Design Research Department between 1984 and 1987. He is currently represented by Krammig and Pepper Contemporary, Berlin, Germany. See www.krammig-pepper.com/Smith_Ausst.htm for more information.

2. Futuresonic (p.19) is an annual electronic music and arts festival and conference in Manchester, UK. See www.futuresonic.com for more information.

3. Prix Ars Electronica (p.23) is an annual festival and competition of technology-based arts held in Linz, Austria. See www.aec.at /en/prix/index.asp for more information.

❝...media art is above all an experiment – one that often brings the creators and proponents of this new art into an association with engineers and researchers❞

Timothy Druckrey

Art, science and technology

At times it is hard to understand the kind of balance that is required in order for an artist to complete work that uses a combination of technologies and specialised subject knowledge. Their ideas develop as part of a dialogue between artistic intention and the technical realisation this depends on.

The implications, both in terms of time and resources of working across the boundaries between art and technology, are immense. Often, the artist is painfully aware that their inability to grasp new concepts and their particular training may make certain kinds of knowledge very demanding for them. This is not helped by a sense that these deficiencies must seem very apparent to the existing communities of scientists and technologists who may be acting as an interface between the artist and the methods they are trying to use. There are tensions here.

→
SGM-Eisberg-Sonde
Agnes Meyer-Brandis,
2005
The visitor has to slowly lower a camera suspended in a cavity beneath the ground. Images from the camera are displayed on the screen. Meyer-Brandis subverts the scientific appearance of the installation's components by the juxtaposition of magical entities whose presence in such a seemingly objective, fact-finding apparatus surprises and then delights.

→
Moony
Akio Kamisato, Satoshi
Shibota and Takehisa
Mashimo, 2004
This work uses water
vapour as both a
projection surface and as
an interactive trigger. This
piece was developed as
part of the Next Idea
Development Programme
at Prix Ars Electronica,
where resident artists are
assisted in the realisation
of their concepts by a high
level of technical
expertise.

Artists may appear to be somewhat dilatory in their approach and even self absorbed, lacking the sort of necessary vigour in their working practices that is second nature to those who pursue the accepted scientific research methods. On the other hand, scientists can seem unhelpful to those needing their assistance, and sometimes unwilling to place their knowledge at the disposal of those whose aims may not be immediately clear to them. These are simple misunderstandings in most cases, and can be attributed to different modes of communication, rather than to any actual desire to obstruct progress.

Scientific research proceeds from one measurable outcome to another, and moves logically towards its objective. For example, a solution to the problem, the isolation of a particular element, or the presentation of quantifiable evidence that opens the way to the commercial manufacture of a substance. Artists also work with similar outcomes at times, but their impetus lies in a desire to find some kind of mediation for a particular experience, and in many cases they work with no definite objective in view as they tend to feel their way tentatively, rather than following a carefully charted route.

❝It has often been said that art is a means of communication but the artist himself is also an inventor eager to discover new methods of improving and facilitating his own techniques.❞

Sir Roland Penrose

Cultural dialogues

Culture could be described as all those things that are taken for granted as part of a certain way of living. It is only when visiting another culture that these accepted norms are seen for what they really are. Changes in the surrounding cultural environment happen almost imperceptibly, which makes it hard to step out of a particular setting and examine what is happening so that some judgement can be made about what is actually going on. The digital artist works on the boundaries of knowledge and has a role in shaping the way a new technology is perceived. The common perception of machines and their significance is clouded by myths associated with their power and dominance. Using a machine is far from being a neutral activity. Machines affect the user at least as much as they empower them.

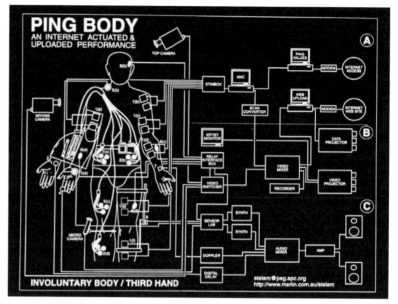

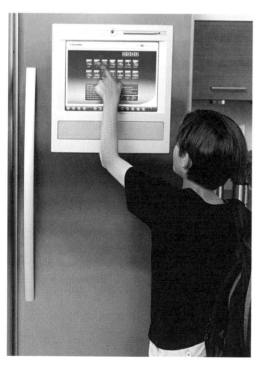

← Electrolux Screenfridge
Image supplied courtesy of Electrolux
Contemporary life is constantly subject to cultural shifts and environmental developments. Sometimes these derive from the availability of a new invention, labour-saving device or a method of communication.

Domestic appliances are increasingly able to interface with networks outside the the home so that they can react to changes and initiate action. The Electrolux Screenfridge includes an interface that allows supplies to be ordered automatically when necessary.

↑ Stelarc
Ping Body, 1996
Stelarc places his extended 'body' at the disposal of an absent networked community, who, by sending commands, are responsible for his resulting syncopated jerks and gestures. 'During the Ping Body performances, what is being considered is a body moving not to the promptings of another body in another place, but rather to Internet activity itself – the body's proprioception and musculature stimulated not by its internal nervous system but by the external ebb and flow of data.' (http://www.stelarc.va.com.au/pingbody/)

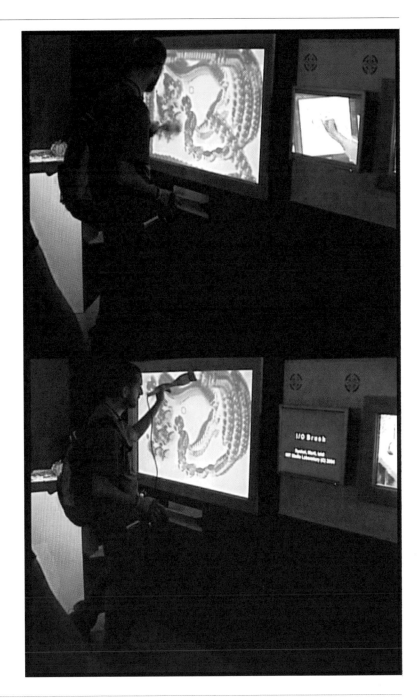

→
I/O Brush
and interactive screen
Kimiko Ryokai/Stefan
Marti/Hiroshi Ishii, 2004
This piece emulates
the touch and sensitivity
of painting with a touch-
sensitive screen, scanner
and brush.

"The artist is a man in any field, scientific or humanistic, who grasps the implications of his actions and of new knowledge in his own time. He is the man of integral awareness."

Marshall McLuhan

↑
Public Information Screen
for the Next Idea
Development Programme
Prix Ars Electronica, 2004
This screen is responsive
to the temperature of the
human hand and does not
require the user to touch
its surface. The user feels
that they only need to
point to create a response.

Sometimes it seems that
society is responding to
change as a result of
inventions that are
happening in parallel with
one another. Ripples
caused by cultural
changes keep widening
out, meeting those caused
by simultaneous
developments elsewhere.
The result is that society
changes and responds in
confused and unexpected
ways and it is only after
some time has elapsed
that the longer term
effects can be
distinguished clearly.

Ringing the changes

Neil Postman's 'Amusing Ourselves to Death' (1985) documents the way in which rural communities in the United States were changed as a result of being opened up to information arriving from a distance via telegraph wires and Morse code, and gives a glimpse of something that is highlighted when a new email appears in our inbox: the importunity of the distant and the resulting backgrounding of the local. Distant information seems more insistent and almost more real than the concerns of immediate surroundings. Suddenly these rural communities served by the telegraph learned of events affecting the lives of people living hundreds of miles from them.

Ask anyone what they were doing at the time of a major news event over the last five years, and they are likely to remember an otherwise ordinary day with a vivid sense of detail. The distant event seems to throw the day into a high-contrast exposure in which an individual can remember minute details of their experience at the time. This is a good example of the way in which a technological invention has implications for perceptions relating to the individual's immediate concerns and significance. A local dispute, for example, may not seem so pressing when compared with news of a mining disaster far away.

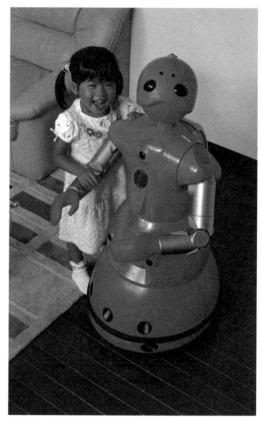

↑
Wakamaru Robot
Mitsubishi, Japan 2005,
Image courtesy of
Mitsubishi Heavy Industries
Ltd.
This robot is designed to
undertake everyday tasks
in a domestic environment
and may be used to
provide 24-hour care for
the elderly living alone.
As it moves around, it
relays video images to
relatives via the Internet.

❝The world is fitting itself into the mould
of the vagabond. ❞

Timo Kopomaa

The shaper of cultural norms

Very often it is the work of an artist, the publication of a book or the release of a film that is able to provide a way in which a society can begin to handle the wider implications of a technological development. Play, reflection, role play, imagination, future gazing or simply just a chance to make personal contact with the technology can be all that is required to open a dialogue that helps the individual to come to terms with what has become possible. The wider impact of such potential may not be predictable, but perhaps these engagements mean that there will be more of an awareness of some of the possibilities that are opening up. An exhibition or an artist's talk can have far-reaching consequences in changing an approach to a technological innovation. Suddenly we see something we had perhaps feared in a completely different light.

This is certainly not to say that all such developments bring only positive benefits. It could well be that with all our information and data we have lost the sense of innate truth that was common currency for slower, less sophisticated societies. With every gain there is also a loss. But in another way there is no position outside our own point in history where we can make an objective judgement of such comparisons against some ideal perfectly balanced paradigm.

Staying in touch on the move

Mobile phone technologies have given rise to a great deal of reflection on the nature of public and private spaces, on our definition of being 'at home' or 'available'. Changing behaviour patterns and a willingness to talk about very personal situations in public underscore the immediate presence of the distant. Mobile phones permit users to roam the extending geography of cities while always being 'at home'. Acceptance of this new technology has changed urban behaviour patterns. Digital artists can create work that follows up on such debates and in doing so draw more people into the discussion.

Fee Plumley and Ben Stebbing of the-phone-book.com carried out a number of projects in this area allowing users to create and exchange content on their mobile phones, commissioning text message short stories and narrative films. Similarly Squid Soup, whose interactive media projects combine experimental research with technical and design know-how, challenged the ephemeral nature of text messages by using them to create 3D structures.

Similar kinds of change are affecting our notions of proportion and relative size with our growing knowledge of both cosmic and nano scales destabilising our acceptance of the significance of our own dimensions. We should continue to expect further advances in these areas and the accompanying challenges to our understanding of what it means for something to be within our reach.

↑
Paul Sermon,
Telematic Dreaming, 1992
Paul Sermon, in both 'Telematic Dreaming' and his more recent work, continues his desire to elicit unforeseen elisions between the real and the virtual version of reality.

Do I behave differently if 'you' are just a projection, rather than an actual occupant of the same space and atmosphere? How much of myself am I prepared to reveal to the one rather than to the other? His work leaves all such questions open for us to answer as we wish.

KB Knowledge Bank

1. www.the-phone-book.com (p.27) is a website that explores the use of mobile phones to explore unusual creative possibilities.

2. Squid Soup (p.27) have used SMS texts within a 3D virtual environment. Visit www.squidsoup.com for more information.

3. Telematics (p.27) is the use of technology to allow for real-time data sharing.

Cybernetic serendipity

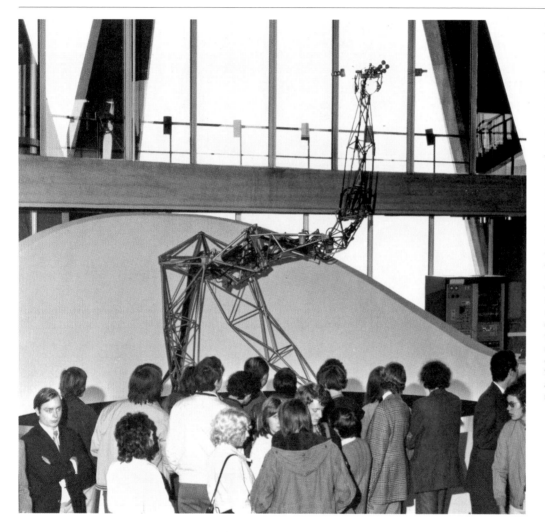

←
The SENSTER
Edward Ihnatowicz
Image supplied courtesy of
the artist's estate
The SENSTER was
developed in the years
following Cybernetic
Serendipity and was
extremely ambitious, both
in scale and intention. It
was exhibited near the
entrance of the Philips
Evoluon building in
Eindhoven, the
Netherlands, between
1970 and 1974. The
SENSTER reacted to
sound, when a visitor
clapped their hands for
example, the SENSTER
moved towards the
source. The same
hydraulic mechanism was
used as Ihnatowicz had
devised for SAM (see
facing page), but this was
now controlled by a
computer, which gave the
SENSTER subtler, organic
and more varied
movement patterns.

⁴⁴Previously I had seen artworks as objects.
Now, they became processes.⁴⁴

Paul Brown (visitor to Cybernetic Serendipity)

The <u>Cybernetic Serendipity</u> exhibition was mounted at the Institute of Contemporary Arts (ICA), London, in 1968. It was an exhibition of computer-produced work by both scientists and artists. Jasia Reichardt, the organiser of the exhibition, carried out three years preparatory research prior to the show. Funds came from the Arts Council with equipment assistance from IBM, and a US State Department travel grant enabled her to visit potential contributors in the United States.

The exhibition took stock of work already completed at the time, and also commissioned special pieces. The content of the show pointed to a whole range of possible directions for the future, particularly in relation to collaborations between artists and scientists. Artists, scientists, computer companies, airlines, musicians, sculptors and poets were all brought together. This was a major show with over 300 people involved and was a watershed event in the history of digital art.

The exhibition's title encapsulated two ideas: that of cybernetics (a science of control and communication in complex electronic machines and the human nervous system), and that of Serendip (the former name of Ceylon, which is now Sri Lanka). In Horace Walpole's story of 'The Three Princes of Serendip', the princes 'were always making discoveries, by accident and sagacity, of things they were not in quest of'. The discovery of these 'happy accidents' led Walpole to coin the term 'serendipity'.

The exhibition had three main sections: computer-generated work (including graphics, animation, music and poetry); cybernetic devices as works of art (including environments, robots and painting machines), and machines demonstrating the uses of computers in relation to cybernetics. Developments in technology had suddenly created a situation where scientists saw the creative dimension of the equipment that they were working with.

←
Sound Activate Mobile
Edward Ihnatowicz
Courtesy of the artist's estate
SAM inclined towards the viewer in response to sound and its smooth movements emulated a living organism. This was made possible by complex electro-hydraulics that were controlled by an electronic system, which enabled SAM to glide from one position to another.

KB Knowledge Bank

Key contributors to <u>Cybernetic Serendipity</u> included:
1. Jasia Reichardt: Organiser

2. Mark Dowson: Technological Adviser

3. Peter Schmidt: Music Adviser

4. Franciszka Themerson: Exhibition Designer

"As comprehensive a coverage of work could be expected in such a new and burgeoning area, it introduced many artists and designers to computers for the first time."

John Lansdown

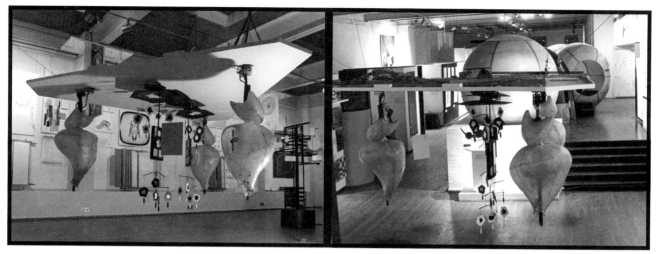

What did Cybernetic Serendipity achieve?

Cybernetic Serendipity provided a pause, a hiatus in which those involved with computers were able to see themselves as part of a larger movement, one made up of many others who had become aware of what might be achieved by using computer technology.

Many artists now working within the digital domain have acknowledged a debt to the discoveries they made as a result of a visit to Cybernetic Serendipity. Paul Brown relates how his visit was influential in his decision to learn programming and electronics some time after his studies and training as a painter.

The great changes that had begun during the early 1970s in art and design education received added impetus as a result of the exhibition, and in the UK a number of key centres for the study of computing in art began to emerge. These included the polytechnics at Middlesex, Coventry and Portsmouth. Crucially, the exhibition provided tangible evidence that a new kind of aesthetic experience was possible, and that a door was now open to interchange between art and technology.

Obey the rules or not?

Computers are able to repeat instructions in a way that is free of any self-consciousness. They obey rules because they have been programmed to do.

Computers have no difficulty when instructed to repeat an action without any variation. Conversely human beings associate repetitive tasks with somewhat oppressive manufacturing processes. Here the worker becomes a cog whose only contribution is as a facilitator within the production cycle.

We often think of keeping to rules as somewhat cold or emotionless. We tend to rely on reason, but we would rather emulate the freedom of the artistic spirit who can break rules if necessary.

The notion of art arising from obeying rules might be seen as central to Cybernetic Serendipity and the show included many works that had resulted from systems set up and executed by strictly adhering to certain procedures. Systems don't question instructions they are given and are very thorough in completing any procedure until the goal has been achieved. However, the interesting thing here was that the results often appeared quite random and arbitrary and not at all rigorous.

The exhibition raised questions not just about the nature of art, but also about human consciousness. Artists included pieces that were 'viable' independent systems – programs that could decide between a number of options. In the following years, this has opened further discussion about the structures governing human reasoning, language development, learning and decision making. This research continues today with the search for the answer to the riddle of human consciousness pursued in fields such as human vision, robotics and artificial intelligence.

An important legacy of the exhibition was the founding of the Computer Art Society (CAS) as a specialist interest group within the British Computer Society. A number of exhibitors such as John Lansdown, George Mallen and Gordon Pask were key in developing this important initiative. The CAS mounted an inaugural exhibition at the Royal College of Art in 1969. Event One exhibited work in diverse fields such as architecture, dance, music, film and the theatre. The common factor in each of these fields was the computer. Event One provided a serious forum for the discussion of developments in computer art.

↑
Colloquy of Mobiles
Gordon Pask, 1968
System and males by
Gordon Pask. Females by
Yolanda Sonnabend.
Electronics by Mark
Dowson and Tony Watts
'It is a group of objects,
the individual mobiles that
engage in discourse, that
compete, cooperate and
learn about one another.
Their discourse evolves at
several levels in a
hierarchy of control and a
hierarchy of abstraction.
The trick is that if you find
them interesting then you
can join in the discourse
as well and bring your
influence to bear by
participating in what
goes on.'
(Taken from 'Cybernetic
Serendipity, the Computer
and the Arts Studio
International' Special
issue 1968.)

Changing priorities for artists

The work exhibited in both Cybernetic Serendipity and Event One was evidence that artists had great problems to overcome in their working methods as they explored the potential of technology. Some of the exhibits might simply be seen as evidence that artists were moving towards the resolution of some of these problems. In this sense they showed process and process development.

Before 1968, other artists had begun to work in ways that reoriented the artwork/viewer relationship as the possibilities of kinetic art were explored. László Moholy-Nagy's Light Prop of 1928–1930 for example, had harnessed the movement of a machine for dramatic results that were recorded on film. Jean Tinguely and Marcel Duchamp had also used movement so that the notion of frozen inert sculpture had received earlier challenges.

These ideas received detailed analysis in Jack Burnham's 'Beyond Modern Sculpture: The Effects of Science and Technology on the Sculpture of this Century' (1968) and in Lucy Lippard's 'Six Years: The Dematerialization of the Art Object from 1966 to 1972' (1997).

"What was significant was that the computer brought in its wake new people to become involved in making art and composing music. People who had never thought of putting pencil to paper, brush to canvas, started making images."

Jasia Reichardt

←
Scanner
James Seawright, 1968
James Seawright's Scanner (suspended from the ceiling), and one of six display cases from IBM showing historical innovations in data-processing machines.

2 Live art: using response

Ever wanted to pick up a toy or a gadget, take it apart and find out how it works? This process is called hacking hardware and we will be exploring its possibilities in the cause of experimental digital art. Please note: the aim here is constructive! The principles of electronics are also introduced in this chapter and it is surprising that even a small amount of knowledge in this area can suddenly make it possible to create work that 'listens' to the viewer.

Unmasking the digital image

The first thing that comes into your mind when thinking about digital art is probably something involving pristine clean three-dimensional surfaces. It will include reflection, transparency, complex light sources and probably some kind of mechanical form.

The film and games industries are concentrating their efforts on goals that are very different from this at the moment, with key concerns being the creation of synthetic actors with all their idiosyncrasies of character and facial reaction. Computer animation seeks to emulate the particularities of muscle movement and elasticity, and the properties of skin tissue and how it behaves in relation to the body structure beneath the surface.

Invisible media

This immense effort and ingenuity is directed towards one main objective. The aim is to make the medium itself invisible to the viewer. The animator's aim is to create a synthetic world that is utterly consistent within its own terms, and allows the viewer to see through the medium. The viewer will only be conscious of the world that has been created and the narrative plot. To be successful, this involves a great sensitivity to the kind of phenomena that we don't even think about most of the time. The properties of different sorts of substance, movement and the way objects behave because of gravity. All this has to be interpreted within the digital environment and reproduced to create an equivalent structure.

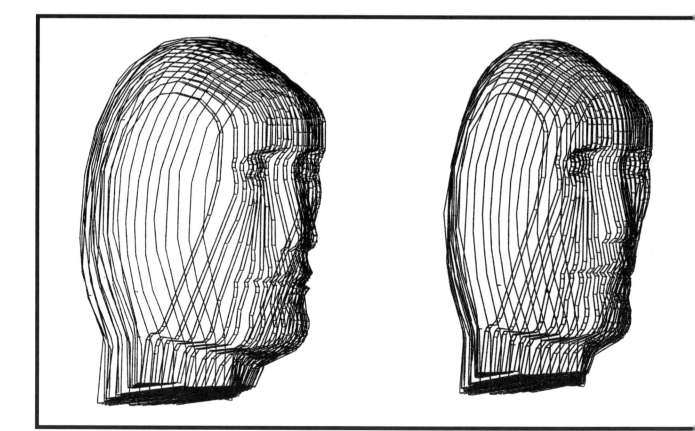

Artists in different cultures and in different times across the world have found various ways of making work that is sensitive to the properties of their chosen medium.

In some senses, their work has greater impact when their methods do not seek to dissimulate or appear to make this medium something that it is not.

The majority of artists working within 3D animation have accepted the notions of space that have come down to us as a result of the discovery of single point perspective during the Renaissance. Sometimes they should perhaps feel that they have the freedom to question this.

Successful work in 3D simulation depends on a considered use and response to aspects of our experience and perception and our knowledge of how materials behave in the world.

"People watch askance as everything that can be digitised (films, music paintings, knowledge, speech etc.) is being turned into the 1s and 0s of computer code for instant transmission down telephone wires or in wireless form."

The Guardian, June 16, 1999

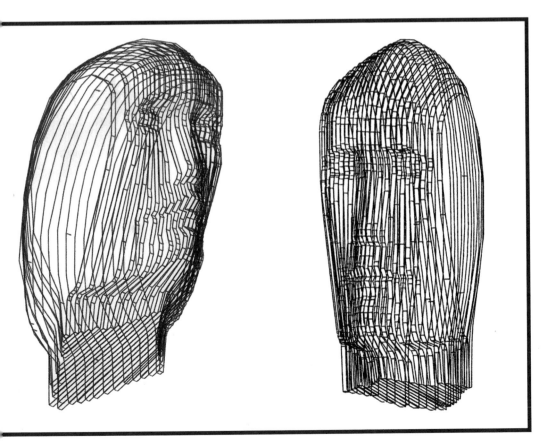

←
Computer Animation
John Clark
Images from a 16mm animation produced by John Clark in collaboration with John Warner and Richard Colson 1987. This example shows the 3D digitisation of a human head produced by combining individual slices of a clay model. Although lacking in sufficient level of detail, it was possible to create a variety of subtle facial expressions by altering the viewing angle.

'Living' images

Some digital artists have concentrated on creating work that has no delay between experience and the resulting 'live' image.

The artist sets up a situation where the imagery changes depending on the actions of the viewer. Here, the image is not the end result of many decisions made by the artist at work alone in the studio; rather, it represents a dynamic collaboration between the artist and their public. The digital image in this case clearly evidences its method of creation, in a direct sense, and in no way seeks to hide this relationship.

A series of different values are made accessible and they are used to alter a number of aspects in the way that the image behaves. Digital images are constructed of pixels (picture elements) and these have colour properties, dependent on the amount of red, green or blue colour values present in each one. Each part of the image is located using a coordinate or grid system and the position of the elements, their size or their movement, can be made to depend on what is happening in the environment.

↗→
Image Recoder
Richard Colson, 2006
The size of each picture element is dependent on how close the viewer is to two ultrasonic sensors that are connected to the computer via the serial port. The data is read by a micro controller. The image data and the sensor readings are combined with customised software in processing. The aim of the piece was to underline the fact that human perception is very far from being objective and that there is a whole range of things that tend to interfere with an unquestioning, uninterrupted gaze at the world.

←

Dark Filament
James Faure Walker,
2006
(114 x 134 cms /45 x 53
inches, archival Epson
inkjet print, edition of 5)
James Faure Walker uses computer software to develop complex textural surfaces, but makes no attempt to hide the sequence of visual decisions so that they each one contributes an element to the final character of the work.

Faure Walker's recent book ('Painting the Digital River', 2006) takes a view of art based on a comparison of digital and more 'classic' pieces and explores the kind of work that can result from a lively interchange between different sorts of media.

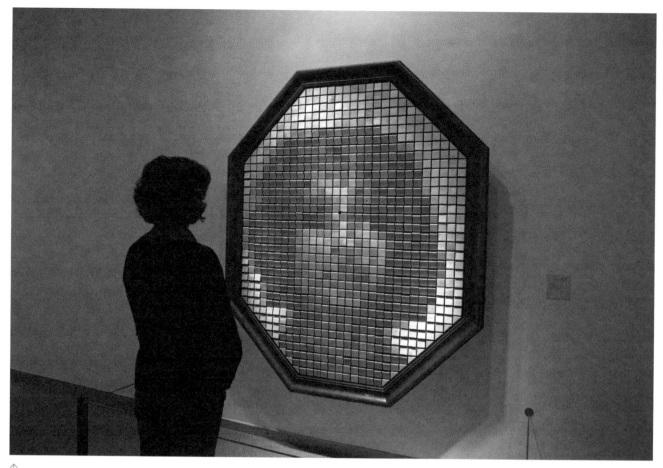

↑
Wooden Mirror
Daniel Rozin, 1999
Produced at Tisch ITP,
New York
Daniel Rozin is one of a
number of artists working
with live video that reacts
within a 'live' environment.
This was his first work
using the concept of an
electronic mirror and
resulted from study at
the Tisch school in
New York. Each of the
mirror's blocks rotates,
and 830 servo motors
control the angle of each
one to reflect a different
amount of light and so
create the image.

"The work of art is the fruit of a process of organisation
whereby personal experiences, facts, values, meanings
are incorporated into a particular material and become
one with it...are assimilated to it."

John Dewey

←
Swarm
Daniel Shiffman, 2004
Daniel Shiffman is
responsible for some
extraordinarily powerful
installations that allow for
'live' interference with a
video source. Customised
software repositions the
pixels in each frame of the
video in real time in
response to the user's
hand on a touch screen.

Analysing vision and experience

Our perception of the world is incredibly complex and current research into how we actually see confirms that there are no easy answers to the problems of the physiology of human vision.

Making a relationship between the viewer and the image opens up possibilities for other types of imaging. The changes being interpreted to alter colour values or position of pixels can also be used to alter the angle of rotation of moving mechanical parts. And these can then themselves result in the display of an image. Technology used in rotating billboards could be controlled by the viewer's movement.

The analogue world around us has tremendous potential as a means of creating images that contain some sort of random content. All that is required is that we find some way of measuring or quantifying analogue phenomena so that they can be used in a digital environment.

In the digital environment, every instruction has to be reduced to a collection of ones and zeros. In the analogue world, I can have a range of values from a minus to a positive.

The translation from one world to the other is the process of digitisation. There is a great deal of fun to be had in carrying through this process.

❝The purpose of the eye is to transduce a particular subset of electromagnetic radiation into neural signals.❞

'Why We See What We Do: An Empirical Theory of Vision', Purves and Lotto, Sinauer 2003

The fundamentals of digital art Live art: using response

←
Loc Reverb
Richard Colson, 2003
Part of the exhibition:
Site Soundings + Digital
Terrains
Digital images that
change as a result of
intervention from the
viewer seek to emulate
the multi layered
complexity of
consciousness. Walking in
the street, I see clearly
everything that is around
me, but my vision suffers
constant interruptions;
objects moving at different
speeds, my own
memories, both short and
long-term, flashing lights,
sounds of all sorts,
snatches of conversation
coming in and out of my
audio range. It is rare to
be able to focus steadily
on one thing without this
sort of visual disturbance
and distraction.

KB Knowledge Bank

1. 'Live' images (p.36) used in this
 chapter require:

 a) an image source (e.g. a
 webcam, a video camera or
 prepared still images).
 b) customised software that is
 able to analyse a sequence of
 images pixel by pixel in real
 time (such as Processing, see
 www.processing.org).
 c) a method of reading changing
 information from the
 environment (such as a micro
 controller, USB board or
 PIC chip).

 Remember, every digital image
 is made up of a grid of pixels
 that you can address
 individually to alter colour,
 intensity or contrast. If you can
 find a way of doing this, you will
 have begun a very different
 approach to the creation of your
 own original imagery.

Physical computing

←
Graphical Mess
Seth Beer, 2006
This customised printer
console has an online
image searcher that
allows images to be
selected and printed and
their position on the
printing floor determined
by radio control.

Physical computing can be defined as the study of any technologies that allow computer input and output from the physical world of our senses.

Artists utilise means of expression with whatever mediums are available to them. This includes the developing technologies that are proliferating in so many forms. Artists' interest cannot be confined to the technology that is used to control what happens on the screen when sitting in front of a computer with a mouse and keyboard.

The technological domain has become more mobile. It is smaller, cheaper and more flexible. Entering this domain as artists means approaching it with the same curiosity, the same need to communicate ideas, and the same sensibility for the materiality that characterises the rest of experience.

Physical computing allows for the collection of data from the world of touch, gesture and any other sort of variation in the environment. A digital device of some sort then receives this information. This communication creates possibilities of a dialogue between the world of phenomena and digital equipment.

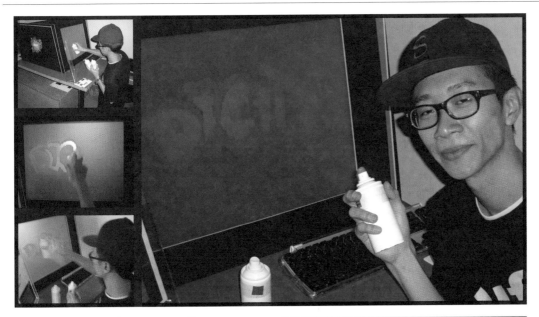

←
DIGITI: Electronic Graffiti
Kenji Ko, 2006
Here, a lighted LED
replaced the paint
spraying from the aerosol
and this gave the user an
unexpected sensation. The
position of the LED was
picked up by a webcam
and painted pixels
appeared on that part of
the translucent screen.

Moving towards a different understanding

To create successful communication between a
particular device and the computer, a micro controller
can be used. The circuit on the micro controller will
understand the analogue information it receives from
the device and will then translate this into a digital
format that will be accessible to the computer. For
example, a potentiometer such as a volume control
will output an analogue value range between 0 and
90. As the spindle of the control is turned, the micro
controller will read the values and is able to pass
these onto the computer.

Other devices such as temperature sensors, proximity
sensors or PIR (pyroelectric) sensors can also be
connected to the micro controller in the same way.
Some will be simpler than the potentiometer because
the value they send will either be ON of OFF, and the
micro controller will read this as either HIGH or LOW.

←
Robot Phase 1
Hedley Roberts and
James Coupe, 2001
The robots could be
commanded to move in a
number of different
directions but visitors
were prevented from
occupying the same
space. Their only access
was via computer screens
outside and their
understanding of the
space was limited to
information from
webcams mounted on
each device.

Connecting two worlds

The realm of physical computing is primarily concerned with making connections. It is necessary to interpret phenomena in the world such as sound, temperature, movement or colour so that these can then be allowed to influence what happens within a structure that is controlled by a computer. These connections need to allow information to travel in both directions, so that the digital information on the computer is also allowed to control the physical world, creating a real-time dialogue.

In order to create this situation in more detail, first the data that is of interest must be obtained. So, for example, change in temperature or movement over time must be measured and recorded.

Secondly the data (or measurements) must be converted to a format that can be read by the computer and transmitted.

Finally the data (or measurements) must be processed; the measurements on the computer must be interpreted and then changes in response can be carried out.

By proceeding in this way, these two domains, the digital and the physical, will become intertwined and interdependent. Each one will be allowed free access to the other. Aspects of the world and experience are harnessed in such a way as to allow them to be captured, and used to modify some kind of a reaction within the digital domain.

Gesture and action have been part of the process of making art since the time of the cave dwellers at Lascaux. As they drew the animals, cave dwellers transferred their experience of the speed of the hunt through their arms and onto the cave walls. With an ability to record the movement of the arm, physical computing creates the possibility of a direct relationship between a stretch and a sound. It opens up the possibility of a vicarious experience. A gesture is made and its result is seen not just in the immediate environment but elsewhere in an equivalent digital world.

KB Knowledge Bank

1. Real-time (p.44) is the immediate moment-by-moment update of information.
2. Vicarious experience (p.44) is experience at one remove.

Reader activity

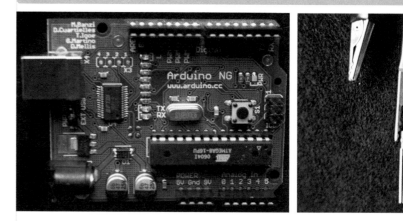

An i/o board

Crocodile clips

Soldering iron, stand and solder

A selection of resistors

LEDs

Clamps (helping hands) and breadboard

Multimeter

Wire strippers and 0.2awg equipment wire in red, green, yellow and white

Physical Computing Toolbox

To get started in any serious way with physical computing, the artist will need a basic set of equipment and tools. Most can be bought at a local electronics shop, but others will have to be sourced via online suppliers. Sensors are also needed and some of these are shown in Chapter 6 (see page146).

A great deal can be learned from following examples on websites such as www.arduino.cc. Attending an introductory workshop on Arduino or processing will help with learning how to set up simple circuits for inputs and outputs.

Reverse engineering

Reverse engineering is the process of discovering the technological principles of a device or object or system through analysis of its structure, function and operation. It often involves taking something apart (e.g. a mechanical device, an electronic component, a software program), and analysing its workings in detail. The purpose is usually to try to make a new device or program that does the same thing without copying anything from the original. In practice, reverse engineering can take one of two forms; either the random hardware approach of 'circuit bending' or the structured hardware approach of 'hardware hacking'.

Circuit-bending

'Circuit-bending' as a practice generally means a creative application of short circuits to electronic devices. The intention is to bring about aesthetic improvements in a particular device's output, and it is almost always done with devices that are cheap and generate audio signals. There is some circuit-bending done with devices that generate video, but not much as the price of such devices is generally too high to make circuit-bending's random (and often destructive) results worthwhile.

The circuit-bending method tends to follow four basic steps:

1. Simple tools (such as <u>crocodile clips</u>) are used to experiment on a device's circuit board; in some instances this will create short circuits.
2. If any short circuit is of interest, a record is kept of where it occurred.
3. Once there are enough short circuits of interest, they are soldered in place with wire to make them permanent, adding in some switches and <u>potentiometers</u> for variation.
4. The switches and potentiometers are then mounted in the body of the device

Other techniques such as replacing resistors with other resistors of different values or variable resistors are used. This works with both older (and rarer) analogue devices in which a resistor might control the frequency of an oscillator and with digital devices where a resistor often sets the playback speed of samples. Simple interface modification is another circuit-bending practice, replacing factory switches with other types of switches or removing the electronic guts of a toy and installing the whole thing in a new housing. Sometimes just simply re-working a device's interface can bring about a completely new way of playing it.

Health and Safety Warning: Circuit-bending is only done on low-voltage battery-operated devices for safety reasons.

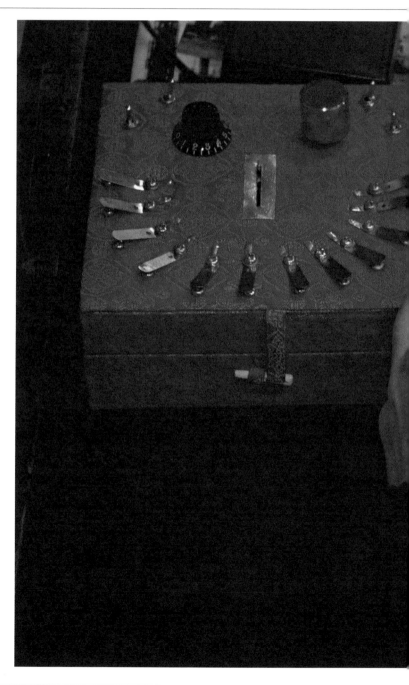

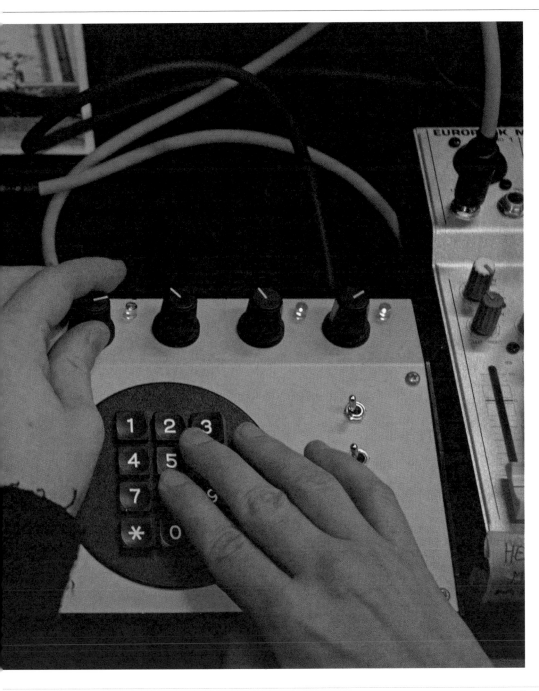

←

The Mao Tai and the Feedback Phone
<u>Sarah Washington</u>

The Mao Tai was created by removing the guts of an electronic children's toy and installing it in a new housing (the red box) in the shape of a smiley face. The original plastic switches, shaped as farm animals, were replaced with simple momentary contact switches (the smile), and circuit bends that alter the sounds were added in the form of small toggle switches and potentiometers (the eyes, nose, etc.). The original sound chip played back samples of trains and farm animals; using the contacts initiates the same sounds from the chip but they can now be modified with various pitch transpositions, feedback effects and distortions by Sarah's circuit bending. For the Feedback Phone, Sarah took a phone keypad and hooked it up to another circuit board added a few toggle switches, LEDs, four potentiometers (the four black knobs along the top) and built a sturdy housing for everything. Pressing the keypad creates short circuits that somehow induce various states of feedback, creating a range of different tones.

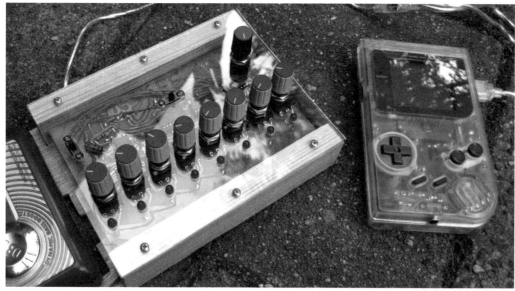

←
Cassette Tape Sequencer
Gijs Gieskes, 2005
Gijs Gieskes is a Dutch
artist and instrument-
builder. In addition to
building a range of circuit-
bent instruments, Gijs has
also designed and built an
analogue sequencer to
control their playback.
Fusing these two ideas,
Gijs created a cassette
player with a controllable
step-sequencer. The
Walkman's tape-playback
speed is controlled by
voltage from the
sequencer via a Nintendo
Gameboy; as the
sequencer steps along it
allows a performer to
manipulate the playback
speed of the tape.

Hardware hacking

'Hardware hacking' is a term used to describe any
method of repurposing equipment that has been
designed for one purpose so that it can be used by an
artist in another way. It is a process of commandeering
existing circuits so that the artist can achieve results
not conceived by the original manufacturer. The circuit-
bending involved in this can spark an interest in
electronic music and electronics and it is not
uncommon for a circuit-bender to develop traditional
skills in electronics so that they start creating more
robust (hardware-hacked) instruments.

Generally speaking this requires a controlled approach
as computers that execute arbitrary code will have
limited results beyond a crash. However, in some
instances a 'guess and check' method with software can
be worthwhile, notably when changing portions of
software which are pre-defined as data and not
instructions.

←
Hacking Nintendos
Paul B Davis, 2005
Taken from 'Big Hand at the
Dice Game', shown at the
Horse Hospital, London
Many devices are actually
computers or are
controlled by computers,
and the programs that
computers run can in
almost all cases be
modified or replaced. This
is what is called 'software
hacking'. A good example
of software hacking is
what Paul B Davis has
done with Nintendo
Entertainment System
cartridges for the past six
years: replacing their
factory-soldered ROMs
with ROMs containing his
own code to be executed
by the NES console
hardware.

→
Naptime
Paul B Davis and
Cory Arcangle, 2004
Naptime is a hacked
Nintendo installation that
was a shown at the 2004
Whitney Biennial in New
York. It ripped a graphic
of a sleeping Mario
(taken from the end of
Super Mario Brothers 3)
and replaced Mario's
dream with psychedelic
flashing characters
while an 8-bit rave track
played underneath.

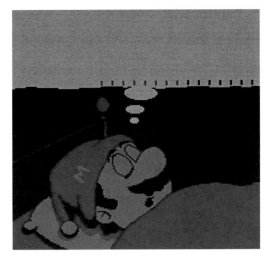

→
Little Sound DJ
Johan Kotlinski, 2003
This is Johan Kotlinski's
Little Sound DJ (LSDJ):
a tracker-style music
program, which runs on
the Nintendo Gameboy.
Using a home-brew
LSDJ cartridge, music
can be written with a
Gameboy and played back
using the Gameboy's
audio hardware.

Using bent tools

While circuit-bent instruments are one-off creations,
software and software hacks are easily duplicated and
distributed. This gives rise to the possibility of making
work on systems that have been 'software bent' by
other people.

There is a staggering amount of code just waiting to be
downloaded from the Net, burnt to ROMs, and used to
'bend' formerly innocent hardware – anything from
various music programs for the Gameboy and Atari
2600 to modified operating systems for Emma
Davidson's Ensoniq SQ-80 synthesiser. Newer systems
such as the Playstation 2 and Nintendo DS have also
been hacked to remove their proprietary code
restrictions, however the complexity of both the hacking
and coding for these platforms means that few art tools
are designed for them and most software is devoted to
playing pirated games or showing off the actual hacking
achievement itself with graphics demos.

KB | **Knowledge Bank**

1. Crocodile clips (p.46) create
 circuits without the need for
 soldering and are useful in the
 circuit-bending process.

2. Potentiometers (p.46) are
 variable resistors in an
 electronics circuit and are
 controlled by turning or sliding,
 as in a volume control

3. Knut Aufermann and Sarah
 Washington (p.47), aka Tonic
 Train, provide an excellent
 starting point for a look at
 circuit-bending practice and
 performance. They are an
 'experimental electronics' duo
 that modify and/or circuit-bend
 their own devices and use them
 in improvised music
 performances. For details, see
 www.mobile-radio.net

4. Gijs Gieskes (p.45) is a Dutch
 artist and instrument-builder.
 For more information, visit
 www.gieskes.nl

5. Paul B Davis (p.48) is an
 American artist and musician.
 For more details see
 www.beigerecords.com

Using feedback

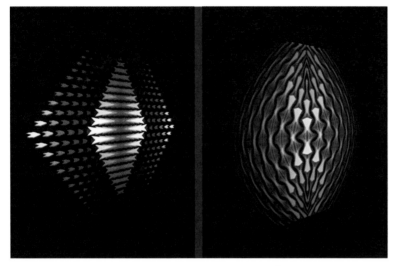

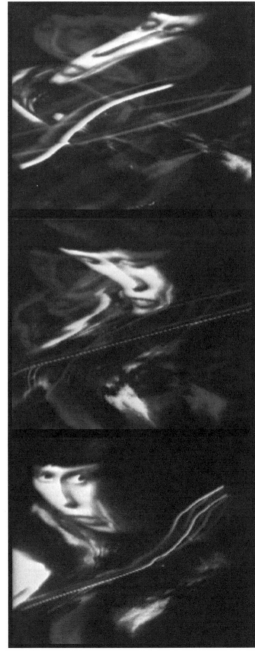

Feedback usually makes us think of those ear-splitting piercing tones that come across a PA system when it is being tested before a concert. Perhaps this is something that we would rather avoid having to experience, but this is only one aspect of feedback. Essentially, feedback is a situation created by a loop cycle, where output is fed back into the same system from which it first emerged. This could be a sound system, a visual system or even a mixture of the two. The common feature is the dynamic live quality of what is happening and the fact that there is a possibility of an artist being able to intervene in some way to influence the cycle. The arbitrary nature of feedback can be directed so that it partly conforms to a specific artistic intention.

In the 1970s, Woody and Steina Vasulka's work forged new sorts of relationships between the artist and technology. The Vasulkas' systems were intricate and difficult to set up. In their case and those of others at the same time, the artist created not a final work but a situation of great creative possibility. Infinite variations were possible, depending on changes made to the systems' settings on a moment by moment basis.

There is now a raft of software environments that allow for the dynamic control and response to sound, video sensor data or MIDI. Some of these are commercial products such as <u>Max/Msp/Jitter</u> packages. Others are open source, such as Eyesweb, Pure Data and <u>Processing</u>.

↑
Stills from Talysis 2
<u>Paul Prudence</u>, 2006
Real-time video processing and feedback
Talysis applies the properties of signal feedback in the same way that one might use a recursive function within a computer algorithm. It evokes the work of the 1960s Op Art movement.

→
Violin CRT
Woody and Steina Vasulka, 1970–78
In the 1970s, <u>Woody and Steina Vasulka</u> explored the way in which sound could be made to cause visual noise in cathode ray tube technologies. A violinist played in a studio and the performance created a parallel sequence of patterns of great visual delicacy on the CRT screen in the same space.

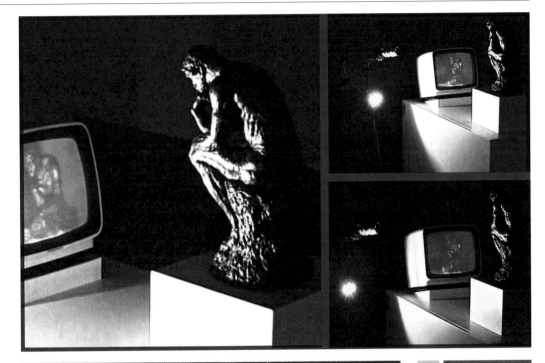

→
The Thinker – TV Rodin
Nam June Paik, 1976–78
Feedback can be self-perpetuating, and not require any sort of intervention. Nam June Paik's work is both serious and playful in the way it creates self-referential loops with media that make the viewer seem as though they are intruding on a self-contained world of image mediating image.

→
Hacking Perl in Nightclubs
Alex McLean, 2004
This image, taken at one of Alex Mclean's 'on the hoof' software art performances, shows how feedback can have immense precision and require considerable intellectual dexterity. Alex notes that:
'If the programmer is to share the continuous artistic process of a painter, their performative movements must be reactive, they must be live. Code must be interpreted by the computer as soon as it can be written, and the results reacted to as soon as they can be experienced. The feedback loops must be complete.'

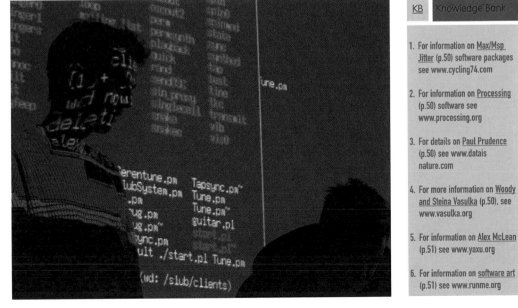

KB Knowledge Bank

1. For information on Max/Msp Jitter (p.50) software packages see www.cycling74.com

2. For information on Processing (p.50) software see www.processing.org

3. For details on Paul Prudence (p.50) see www.datais nature.com

4. For more information on Woody and Steina Vasulka (p.50), see www.vasulka.org

5. For information on Alex McLean (p.51) see www.yaxu.org

6. For information on software art (p.51) see www.runme.org

Communicating digitally

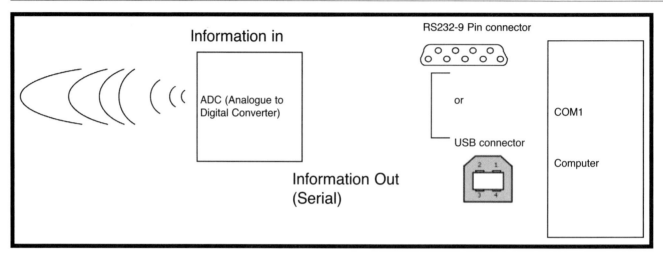

Information in

ADC (Analogue to Digital Converter)

Information Out (Serial)

RS232-9 Pin connector

or

USB connector

COM1

Computer

At machine level, computers understand information only in terms of <u>binary values</u>: 1s or 0s, ON or OFF. Data or information has to be prepared in this way so that it can be described in this format; this process is called digitising.

All sorts of information can be captured in binary values, including images, audio and sensory data. Images have to be converted to a grid of pixels (picture elements) with colour values for each one referenced by their location and specific amounts of red, green and blue (<u>RGB</u>). These values are held in the computer's memory in a structure called an <u>Array</u>. Audio information can be digitised in a similar way, with analogue values of the frequency converted to <u>8-bit</u>, <u>16-bit</u> or <u>32-bit</u> digital sound files.

For both images and sounds, analogue to digital conversion is used to prepare material so that it can be further developed on a computer. The resulting images can then only be printed and sounds heard on a loud-speaker, if the information is converted back to an analogue format once again.

The computer can act to interpret the sensory world of experience, making it available as digital information. Here lies much of the challenge because in order to make this experience accessible, ways have to be found to describe it so that it can be accurately transcribed.

It is worth bearing in mind, however, that this process of interpreting information is not neutral and does affect the material in particular ways. There are losses and gains that must be taken into account.

We have discussed images and sound, but what about other sorts of phenomena? How do you capture gesture, pressure, temperature changes, the height of the sea level or the numbers of people in the room so that you can send this information from one place to another on a computer network? In these cases you will need a sensor designed to measure the change that is happening together with an analogue to digital converter (ADC).

↑
Diagram showing ADC (analogue/digital converter)
Information is collected by the sensor and this is read by micro controller, (e.g. PIC, a BX-24 or Arduino) and converted to digital format and sent via a USB or serial cable to the computer. Micro controllers have their own software development environment that needs to be learned. There are online communities and support networks and it is possible to find ready-made solutions for most kinds of application.

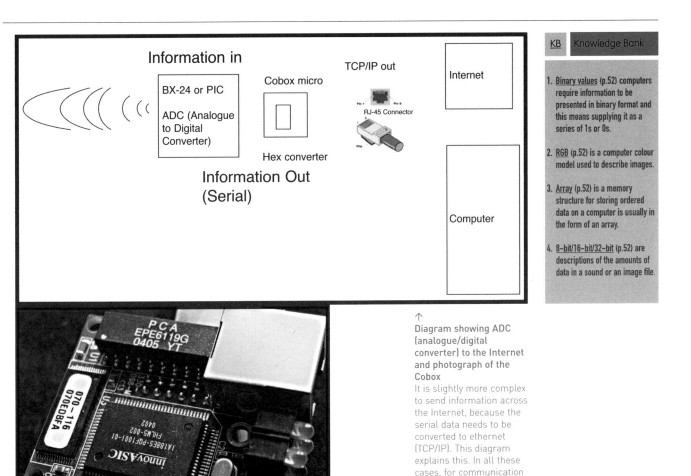

Information in

BX-24 or PIC

ADC (Analogue to Digital Converter)

Cobox micro

Hex converter

TCP/IP out

RJ-45 Connector

Internet

Computer

Information Out (Serial)

KB Knowledge Bank

1. Binary values (p.52) computers require information to be presented in binary format and this means supplying it as a series of 1s or 0s.

2. RGB (p.52) is a computer colour model used to describe images.

3. Array (p.52) is a memory structure for storing ordered data on a computer is usually in the form of an array.

4. 8-bit/16-bit/32-bit (p.52) are descriptions of the amounts of data in a sound or an image file.

↑
Diagram showing ADC (analogue/digital converter) to the Internet and photograph of the Cobox

It is slightly more complex to send information across the Internet, because the serial data needs to be converted to ethernet (TCP/IP). This diagram explains this. In all these cases, for communication to be successful the data needs to be in the correct format and arrive at the speed expected by the device. Each end of the communication needs to be talking the same language. These specifications are usually referred to as a protocol.

Dynamic spaces

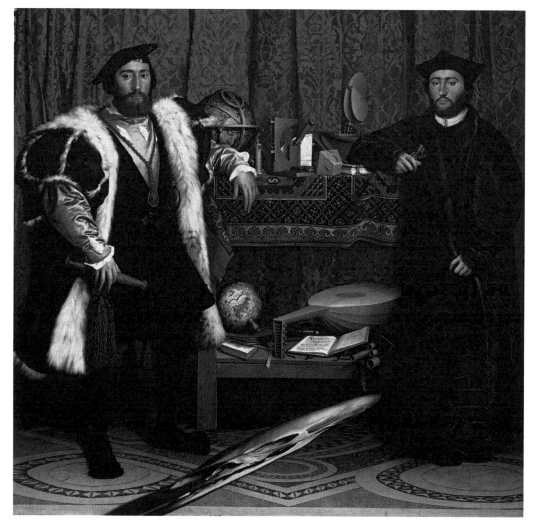

←
Jean de Dinteville and Georges de Selve ('The Ambassadors')
Hans Holbein the Younger, 1533
Copyright The National Gallery, London
It is tempting to feel that interactive artworks are only a very recent phenomenon. However, when you stop to think more carefully about artwork from the past, you soon realise that there are examples that did require their audience to do more than simply taking up one position in front of the piece. The Ambassadors by Hans Holbein appears to be a portrait of two men with a slightly strange foreground. The foreground only makes sense when the painting is viewed from the side and a distorted skull is revealed. The dimension of time and the continual certainty of death provide a strange subtext to the confident image of these successful men.

Interactive works by their very nature are demanding in a gallery space. They attract attention, require a great deal of maintenance, and also a level of involvement that is different from works that are nailed to a wall and do not move again.

Many of these interactive artworks combine a number of media so that the senses are stimulated on visual, auditory, or even tactile levels, and this can be disconcerting for an unsuspecting visitor.

There may be a tendency to consider some of this work as falling into the same category as a game and there may be a great deal of overlap between art and games in this context. The fact that an element of performance may be involved makes it even more likely that this kind of connection is made in the mind of the viewer.

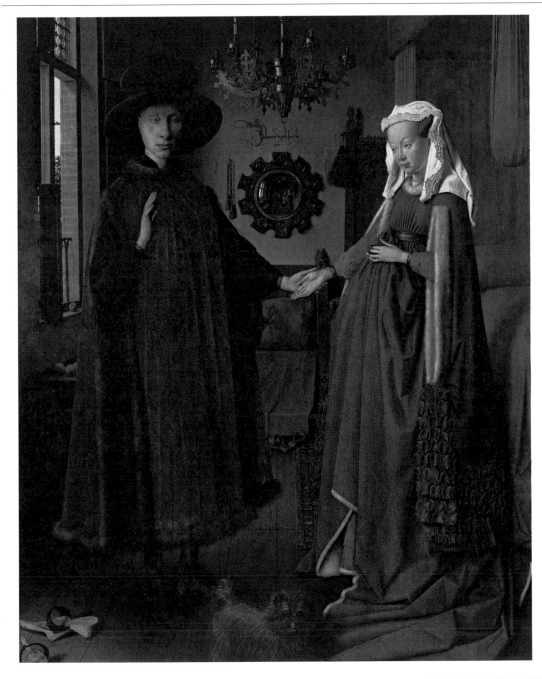

←

**Portrait of Giovanni
Arnolfini and his Wife
Jan van Eyck, 1434
Copyright The National
Gallery, London**

Jan Van Eyck's Arnolfini
Portrait includes a
beautifully painted mirror
in the background in
which we see the backs of
the two figures who are
facing us. Looking at it
carefully we see the room
in which they are standing,
and we also realise that
our own reflection should
be there in the empty
space. We are drawn into
the work, because the
artist builds our
expectations but then
denies us the sense
of resolution.

**Features to consider
when thinking about
interactive artwork**

1. Uses of space, time
 and sound.

2. Use of gesture and
 movement or haptic
 experience.

3. Immersive experience:
 the reinterpretation of
 physical data in a
 virtual equivalent.

4. The artwork as
 collaboration.

5. The combination of
 more than one location
 using networks.

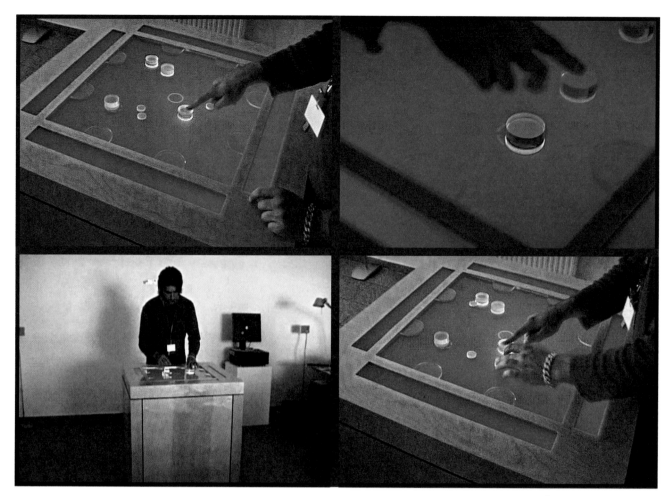

The gallery experience

When a visitor enters an interactive space, it becomes immediately clear that they are now part of an audience. The visitor's actions may be studied, and they may also be aware that there are certain expectations as to how they should react in this situation. In this context, it is difficult to retain the personal responses that can be kept private when viewing painting or sculpture. A common reaction to this is to use humour to try to release any tensions. But humour can undermine the visitor's ability to respond with the same concentration that might be reserved for other kinds of work. The visitor also experiences these works at one remove, because while they are engaged themselves, there is also a consciousness of the actions of fellow visitors around the space. This flavours the experience with a sense that the visitor is part of a community or audience, and introduces another more public layer to their role as viewer. These considerations are characteristic of this sort of work within the gallery context and they need to be taken into account both by the artist and their public.

↑
ISS-Cube
Markus Quarta
This piece uses a webcam to locate the position of brightly coloured counters that visitors can position on the glass surface. In response to these movements, sequences of sound can be selected and mixed. Four speakers are located some distance away, in line with each corner of the cube. ISS-Cube provides a public space for social interaction.

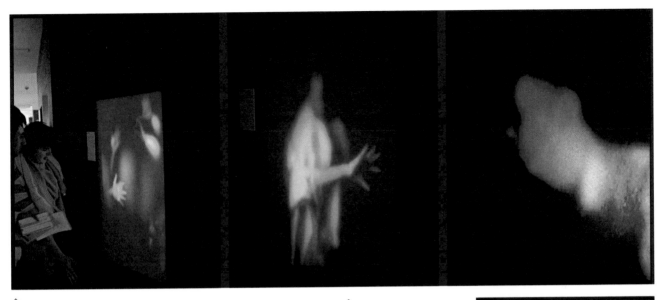

↑
Memory Mirror
Daniel Kupfer, 2006
Memory Mirror retains an after image of the user as they touch its surface, allowing for a visual dialogue with a sequence of images over a period of time. These images are from an installation of the piece at the MA Interaction Design Degree Show, Royal College of Art, London.

→
Messa di Voce
Golan Levin, Zachary Lieberman, Jaap Blonk and Joan La Barbara, 2003
Messa di Voce is a concert performance in which the speech, shouts and songs produced by a pair of abstract vocalists are radically augmented in real-time by custom interactive visualisation software. These images are from an installation of the piece at CyberArts 2004 O.K. Centre for Contemporary Art, Linz, Austria (Prix Ars Electronica Exhibition).

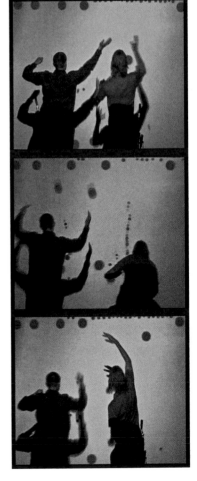

❝Many interactive artworks are designed exclusively for one person at a time, which presents a challenge when showing interactive works in conventional gallery settings. However, works also exist where multiple users actually enhance the works, for the audience can not only interact with artworks, but with each other too.❞

Beryl Graham

Electronics in the studio

←
Students at work
Electronics are not tactile in the same sense as clay or oil paint. There is little fluidity in placing components on a breadboard. However, there is still an element of experimentation, and something of the unknown that can always be discovered. Unlike other kinds of media, there are also conventions concerning electronics, specific health and safety issues, and a body of good practice that it would be rather foolish to ignore.

Traditionally, artists use their knowledge of the tactile properties of materials as a major component of their working process. This understanding of the way that materials behave allows them to expand their creative horizons. The medium itself provides them with an arena in which their ideas find new sorts of form and often happens as a result of very exploratory working methods.

Electronics does not lend itself easily to this approach to working. It is completely logical and demands adherence to specific laws and formulas. Artists tend not to be like this as a general rule, and a different set of skills is needed to work out where a circuit is broken and then solve the problem.

This does not mean that artists who use electronics cannot be experimental. It simply requires an understanding of the medium and the implementation of effective strategies for achieving results.

❝Electronics is perceived as rigidly logical, but in practice it's more like cooking. You have to follow some set recipes to begin with, but the more you do it, the more you realise that you can and should change those recipes to suit the situation.❞

Tom Igoe (from an email to the author)

←
Image Recoder (BX-24 circuit with ultrasonic sensors and laptop)
Richard Colson, 2006
This image shows an Image Recoder at an early stage in its development. In order to be able to read the user's distance from this piece, it was necessary to use a <u>micro controller</u> as an interface between the computer and the ultrasonic sensors. The computer received the sensor data via the serial port and this then controlled the location and behaviour of parts of the image on screen.

↑
Studio Shots
The Interactive
Telecommunications
Programme (ITP) at Tisch
School of the Arts, New
York University
Tom Igoe and the rest of
the Faculty at ITP have set
the standard for student
achievement in physical
computing. This course
attracts students from a
variety of backgrounds.
Students are keen to work
on the boundaries of
existing technologies and
knowledge.

Setting up

One thing you need to get right is a good working
environment. Ideally this needs to be somewhere with
good light and where everything can be left as it is when
you have finished for the day so that you can carry on
where you left off the following morning. Electronic
components can be damaged by static current or by a
stray wire carrying 5V and you need to try to guard
against this kind of eventuality.

Neatness is important as well. It is much easier to
locate a problem if you have followed a logical layout
and can trace back your circuit section by section. It is
also important when you're collaborating with others
because they will be able to see what you are trying to
do without having to separate tangled wires.

Basic electrical circuits

A basic electrical circuit consists of a source of power, connecting wire, some kind of resistance such as an LED and perhaps a switch to close or open a circuit for the flow of electricity. It all becomes much more interesting when you can add into the circuit a micro controller that can respond to highs and lows on a circuit and then send a signal depending on the information it receives. There are a number of different makes such as the BX-24, PIC and Arduino based on the ATMEL ATmega8 chip.

These micro controllers have a very small amount of available memory. But this is programmable from the computer so that once these instructions have been uploaded to the chip, it is independent and can be hidden inside a sculpture, a robot or on your person. The power required is 5V, and this could come from a power adaptor that in some applications will need to come from an on-board battery.

Your essential kit will include:
 A soldering iron and stand with solder
 A 0.2 awg solid core wire
 A selection of resistors
 Helping hands (clamps) with magnifying glass

Multimeter
Connector strip
Header strip
Insulating tape
Breadboard
Wire strippers
Wire cutters
DC motor
Power plugs and jack
LEDs
Switches
Safety goggles

Other components will depend on the kind of application you want to create. Movement can be sensed through the photo-sensitive cell, or a tilt sensor could be used to control a response to a change of angle. More precise proximity management will require an analogue device such as an ultrasonic sensor. The important thing is that the idea should not be determined by what electronics make possible. It should be more dominant than the technology, because unless this is the case, the person viewing the work will be aware of how it is made, rather than its qualities as a complete work of art. The aim is to make the technology invisible in order to give complete clarity to the idea.

KB Knowledge Bank

1. Micro controllers (p.59) are available from a number of manufacturers. Visit the websites of each one and look at the kind of projects that have been completed with them to get you started.

2. For more information on BX-24 (p.61), see www.netmedia.com

3. For more information on PIC (p.61) see www.microchip.com

4. For more information on Arduino (p.61) www.arduino.cc

3 Data into art

Data is coming into its own as a vital resource in the production of significant artworks. In this chapter we will be looking at how it is used, the interfaces for different sorts of data and the kinds of work that have resulted from this art–data relationship.

Data as a creative asset

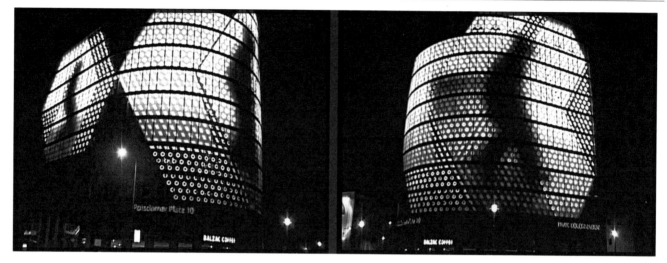

Every individual has to provide personal information on a regular basis as part of daily security procedures. Government policy is often dependent on focus groups and the results of opinion polls and having control over this sort of data is evidence of power. Without data to back it up, an argument lacks the level of impact that is required to influence opinion, and does not carry the necessary weight with key decision makers.

Ever since Kafka related his relentless vision of the individual caught within a faceless but powerful bureaucracy, centralised data gathering has tended to be regarded with suspicion. Even with the best will in the world it would be a very unusual government that did not use the enormous power that derives from access to so much personal information on each and every one of its citizens.

So what's the attraction for artists? Digital artists have worked with data for a number of reasons.

The first of these comes from a desire to confront such a widely held feeling of unease when considering the power of data within society.

The second is simpler perhaps. Artists work with found materials; those things that tend to be overlooked by everyone else. Data can be found in abundance in an information-based society and for artists it is a 'found' material'.

The third reason is that data is dynamic. Data is a live material in the sense that it may be updated moment by moment. Live digital art depends on this constant refresh of the data source.

↑
Gait Studies in Low Resolution
Jim Campbell, 2006
(SPOTS media installation at Potsdamer Platz, Berlin)
The images on these pages by Jim Campbell show how data, once it is available, can be utilised in very different contexts. The images are constructed using a grid of lights or LEDs. The light level of each individual element can be addressed and controlled to create an appearance of movement across the grid's surface. In this case the image is displayed on a public building.

↑
Ambiguous Icons
(Motion and Rest
Series #1)
Jim Campbell, 2001
In contrast to 'Gait Studies
in Low Resolution', this
work is designed to be
seen at a scale more
suited to a gallery wall.

The challenge of data

Artists enjoy working with things that are overlooked by others, and there are many instances of original work based on their handling of statistical and other forms of data. The major challenge is to provide such data with an interface that is appropriate and allows it to contribute effectively to the artist's idea. It also needs to help the viewer to see the data being used in a different context as well as making it accessible. The accuracy of the data being used in this kind of work is not compromised but the artist transforms it, reconfiguring it on their own terms within a new kind of structure.

Imagination and data are two words that might not seem to fit very easily together. Data's importance seems to come to the fore at a mundane level when there is a necessity to get a job completed. Its systems depend on a very materialistic view of the world where everything is measurable and a little bit predictable.

On the other hand, imagination is needed at the beginning of any idea and is associated with innovation and progress. When the imagination comes into play, expect the unexpected.

→

**The Human Form – ASCII
Lawrence Hawker, 2003**
Artists continue to engage in the in-between world created by images that are both alphanumeric character and also some form of response to perceived reality. These figures move in and out of the perceptual grasp. At times, the letters from which the figures are constructed seem to be most insistent, but then become almost invisible as the attention is drawn to follow the movement.

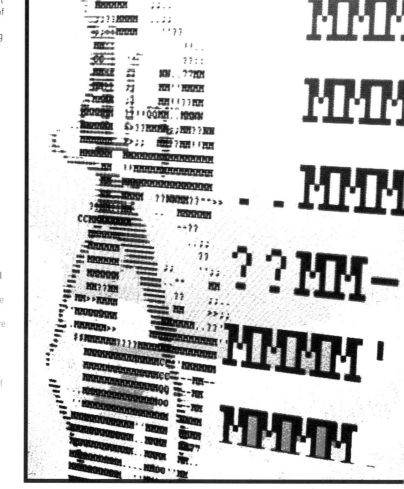

❝We live in a world where there is more and more information and less and less meaning.❞

Jean Baudrillard

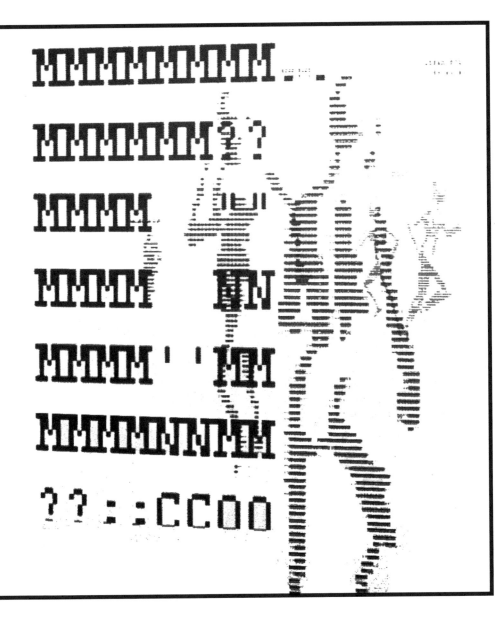

↑
Live data in a global market

Walk into any stock exchange or financial centre around the world and the frenetic activity of the dealers is punctuated by the constant blinking of the changing stock values on the banks of monitors on the desks in front of them. Time spent in these environments enforces a sense that global markets never sleep.

Comparing the working methods of commerce, science and art

Digital artists have a role to play in influencing the way in which others approach the data that has been made available. They can open up all sorts of possibilities for new kinds of collaboration between science, commerce and artistic intentionality. They can also show how data can become the means by which communities are drawn into discussion about key social issues such as local amenities, access to technology, training or other important agents of social change and improvement.

The Internet provides a facility for two-way traffic and data can pass in two directions, collecting and disseminating dynamic content.

The impact of work that uses <u>alphanumeric</u> characters as a medium (such as Studies in Perception 1, shown above), lies in its open acceptance of its means of production, while continuing to centre concern on representation of form and surface. It is as though the world of the imagination was not really the goal, but was opened up, almost unintentionally. The viewer has to keep rehearsing the marks from which it is made and this process keeps it snagged in the visual memory. This was a 3.7m (12ft) mural.

↑
Studies in Perception 1
Kenneth C Knowlton and
Leon D Harmon, 1966
Image supplied courtesy of
Kenneth C Knowlton
In the 1960s, artists engaged with the possibilities of image making using the limited means of representation provided by an ASCII printer. When text is used in the normal way, it communicates a message in verbal form. Here, alphanumeric characters were used with a different intention. They were still printed letters but took on a secondary level of significance as a means of representing figures or other aspects of visual phenomena. The everyday material of text became a medium of a different order.
→
EAT 22 (www.eat22.com)
Ellie Harrison, 11 March 2001–11 March 2002
Everything eaten for one whole year between Ellie Harrison's 22nd and 23rd birthdays was photographed and details recorded in a log. This is a limited edition print featuring all 1640 photos from the year.

❝This sort of experience of multi nodes and multi-threaded spaces, demands a refined gathering of data.❞

Stanza, 2006 (from the artist's statement at Creative Software, NODE.London)

What kind of data can be used by artists, and how can it be managed?

These are some ideas of the different kinds of data that have been used by artists in their work. It might be helpful to consider these in different sorts of categories and take some account of the kind of technologies that will be needed to collect the required information.

1. Local data from the immediate environment

Database information available on a computer's local hard drive.

Data from the environment such as webcam responses, sound, tactile inputs, temperature, movement or position.

Technologies required

PHP, MYSQL for database enquiries and data collection.

Sensors, webcams, micro controllers.

2. Data collected via the Internet using user inputs or requests

Database information that is dynamically updated remotely and made available over the Internet such as stock exchange values, currency rates, commodity prices.

Data collected at a remote location, from a specific environment, and then sent to a remote server so that it can be used elsewhere. There can be similar kinds of information within the local environment. This kind of data is used in online gaming and remote robotics.

Technologies required

PHP, MYSQL for database enquiries and data collection.

Access to the Internet.

Sensors, webcams, protocol converters (HTTP to Serial, Serial to HTTP) micro controllers.

3. Information collected from different places, and then made available to control events at one specific location

GPS (global positioning system) information about the current location of large sea mammals.

GPS data from taxis within a city.

The location of visitors to a conference.

Technologies required

GPS receiver and transmitter.

Access to the Internet, programmed to interpret and use GPS data.

![Falling Numbers artwork — numerals descending on a black background]

Falling Numbers
Richard Colson

Numbers may be just numbers, but they can represent critical contemporary statistics that have consequences for people around the world. It is important that we accept responsibility for data that is available and that it is not seen as something neutral and without real significance. All knowledge carries with it implications for action, and any data that is used must necessarily entail some sort of reaction at the point where it is collected and evaluated. Projects that seek to underline this interdependence between one place and another are crucial in changing a mind-set so thought can be global but lead to local action.

KB Knowledge Bank

1. Alphanumeric (p.68) is a collective term used to identify letters of the Latin alphabet and Arabic digits. The alphanumeric character set consists of the numbers 0–9 and letters A–Z. There are either 36 (single case) or 62 (case sensitive) alphanumeric characters.

2. PHP (Hypertext Preprocessor) (p.70) is server side language that is invisible to the viewer but adds functionality to a web page.

3. MYSQL (p.70) is a piece of software that is used to describe databases. It has an instruction set for writing and retrieving data. The data is accessible across all platforms.

"To live in a period where too much seems to happen. Major symptoms include addiction to newspapers, magazines and TV news broadcasts."

Douglas Coupland, 'Generation X' (Abacus 1991)

New displays for interpreting data

In a contemporary context that privileges the global accessibility of data over its regional or national relevance, the search is on for communication methods that are free from the local idiosyncrasies that will not be of interest to an international audience.

If data is not dependent on language in order to be communicated, it will become available to the greater part of this audience very quickly as there will be no need for the delay caused by time spent on translation.

↑
Making information accessible
Photo: ITN
Information resonates in certain ways, because of the context in which it is made available. For example, a news presenter's manner can flavour an item, so that the viewer responds to it with more or less attention, depending on tone of voice or facial expression.

Australian coast's most powerful

Thousands of residents are left homeless by Queensland's batteries

aunt returns to Nigeria to see how things have changed.

"We're interested in just this idea of sound tracking news and how it impacts on the way we receive what is inevitably biased reportage. News is always biased in some respects, wherever it comes from."

Jon Thompson

↑
Decorative Newsfeeds
Jon Thomson and
Alison Craighead, 2006
In their piece for the Art and Money Online exhibition, these artists allowed a visitor to choose from a number of soundtracks to accompany items from news site CNN interactive. Each new section of live data from the news feeds creates its own arabesque, a pulsing visual rhythm made from the contents of a news wire.

The fundamentals of digital art Data into art

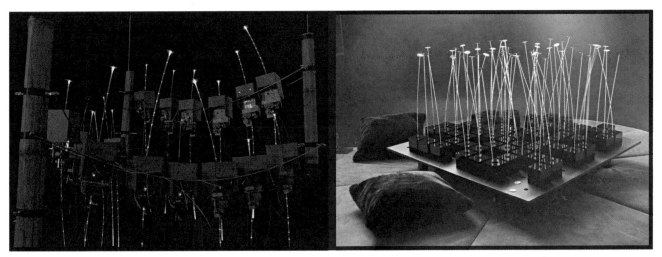

Cyclone.soc
Tom Corby and
Gavin Baily, 2006
This work provides a
perfect example of a
method whereby a way
of handling one sort of
data (weather) can be re-
purposed to present fairly
extreme discussion
contributions within online
religious extremist
newsgroups. Cyclone.soc
re-appropriates
meteorological software
tools so that text from
these exchanges is then
made to animate along
the contours showing the
different centres of
hurricane activity. In
addition to being visually
engaging, Cyclone.soc,
in its use of this software,
suggests that there may
be parallels between
extremist ideas and
dangerous weather
conditions. Contour maps
are familiar as a way of
representing changing
dynamic data. Only a
small conceptual leap is
necessary to accept the
transposition of the highly
charged online exchanges
into this rather strange
new context.

Making information accessible

The way in which information is presented can
determine whether it is communicated effectively or
remains opaque and remote, separate from the
audience for whom it is intended. The reasons for this
may be mainly to do with:

 the volume of other information that is competing
 for attention
 the internal dynamic of the information as part of an
 ongoing story
 the significance of the information within the mind of
 the audience
 the immediate emotional impact of what is reported.

For data displays to be effective, they must address the
same key areas of functionality. They need to be
designed so that the data is:

 legible and clear
 can be updated
 is as objective as possible and free from bias
 can be easily assimilated for quick comparison.

What prevents information being accessible?

In an increasingly specialised world, the conventions
within disciplines have to be resolutely adhered to by
all members of the community of individuals working
within a particular subject area. The advantage of this
is that there is less opportunity for misunderstanding
amongst members who make up the group.

The disadvantage, however, is that there is a loss of
potential interchange with those outside these interest
groups. Outsiders will not have the necessary access
to the tools to decode the information being presented,
and therefore may feel cut off and excluded. This may
be a completely unintentional result but awareness that
this is happening is the first step on the way to
improved openness and transparency, both inside and
outside a specific group of experts.

GORI.Node Garden
Jee Hyun Oh, Allan Au,
Erik Kearney, 2004
The GORI.Node Garden
has been developed as a
series of networked
experiments since 2004.
GORI is an artificial plant
that is nourished by data
created through
networked communication
between people. The
garden changes in
response to the quantities
of activity, with each
plant's height dependent
on a number of posts and
replies in a chat room.
In the project, gardening
is compared with
'networking'; a network
user for example, is
described as a 'gardener'.
Each GORI vibrates during
'watering time' as though
they were plants moving
in the wind.

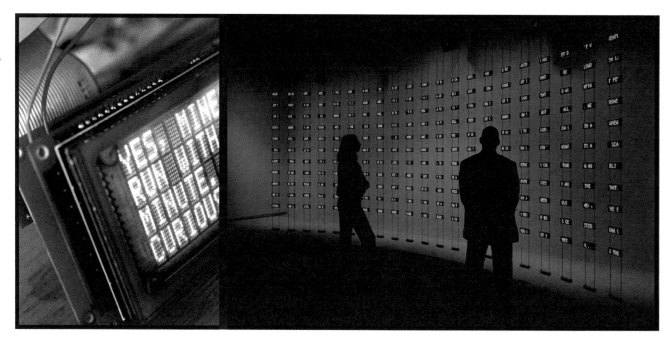

The achievements of digital artists using information

Digital artists have made great gains with their use of information. First, they have created work that reveals the way information can be radically coloured by the method selected for its communication.

They have focused their attention on discovering methods that will enable a process of transcription so that information that seemed neutral and without any real urgency can take on a much more personal significance for the audience. In order for this to happen, the information needs to be seen as making an important contribution alongside what is provided by other outlets so that it is no longer in an unconnected vacuum but becomes part of the accepted current affairs landscape.

Secondly, they have shown how new digital tools have provided an arena in which artists can explore the way information can be represented, making radical use of visual, tactile and auditory sensations.

Pi and bar charts in fully realised 3D imaging come packaged with office software. This method of displaying data is an accepted part of any presentation of accounts in every board meeting. But 3D imaging can be cold and remote from our experience. What if we could output a 3D sculpture of a diagram? Surely this would have greater impact and presence? This would give the data both a visual and a tactile dimension.

↑
The Listening Post
Mark Hansen and
Ben Rubin
Chat room activity is used both by the Listening Post and the GORI.Node Garden (previoius page). Both pieces recontextualise the received data. The Listening Post picks the most commonly occurring phrases in chat room conversations, speaking out what is normally only ever seen on screen.

KB | Knowledge Bank

1. For information about <u>Decorative Newsfeeds</u> (p.73) see www.thomson-craighead.net

2. For more information about <u>Art and Money Online</u> (p73) see www.tate.org.uk/britain/exhibitions/art/art_and_money_online/default.shtm

3. For information about <u>Cyclone.soc</u> (p.75) see www.reconnoitre.net

4. For information about the <u>GORI.Node Garden</u> (p.75) see www.gorigardeners.net/two.php

5. For more information about <u>The Listening Post</u> (p.76) see www.earstudio.com/projects/listeningPost.html

There's another curious aspect to this work...if you can come up with a visualisation of the stock market, which allows pattern recognition, then this could be an instrumental... in making capitalism more efficient.

Julian Stallabrass

↓
Black Shoals Stock Market Planetarium
Art and Money Online, Tate Britain, London 2001
The artists here were able to create a compelling visual equivalent for the real-time data coming from the stock and share transactions on the global stock market. The concentrated groupings of constellations represent the stocks of larger companies and show the relative volume of transactions occurring throughout the world.

Intelligent environments

There is a natural suspicion of environments that seem to 'be alive', and aware of the visitor's presence. It is unnerving to feel that free and spontaneous actions are being recorded and that they have become active agents within an unseen world of hidden control systems.

On the other hand, climatic change and environmental concerns demand that energy resources are used as efficiently as they can be and it is now common practice for new buildings to have an inbuilt capacity to control heat and light so that unoccupied rooms are no longer allowed to consume valuable power.

Professor Warwick at Reading University has had electronic chips implanted in his body so that it is in constant communication with his surroundings as he moves around the University's campus. Doors open and close to make way for him and his location is mapped continuously. This is not an approach that is likely to find much public acceptance, but it points the way to the possibility of a new sort of relationship between the world of the physical body and the built environment.

←

Sloth-bot, i-DAT
Plymouth University, 2006
Plymouth University's new building programme took the challenge of intelligent spaces seriously, and Mike Phillips's research in this area resulted in the installation of a monolith, the Sloth-bot. A demonstration of mobile feng shui, a robotic monolith moves very slowly around one of the public areas within the building. Its position and angle change imperceptibly, in response to the activity of faculty members and students within the space.

→
Come Closer
Squid Soup, 2005
Come Closer uses
wearable technology and
collaborative interaction to
explore and challenge
the sense of personal
space and proximity to
others. Digital artists have
used the idea of hidden
data sources to change
the role of the viewer in
relation to the work of art.
Small device Internet
servers can transmit
readings from equipment
in one environment so that
there is a corresponding
change in another remote
location.

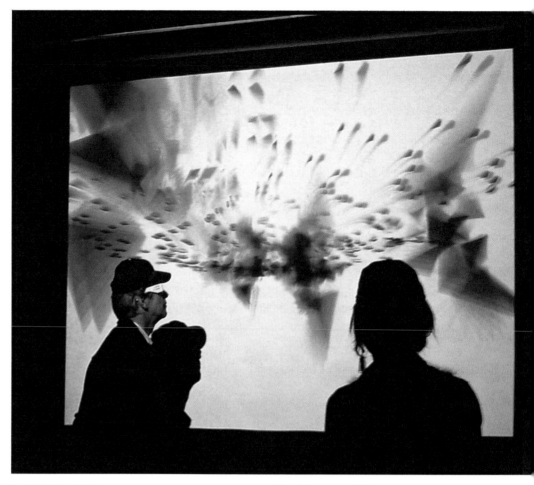

Invisible data traffic

Wireless networks and technologies such as Bluetooth
and infrared facilitate data exchange and social
interaction based on proximity of device. Walking
through a section of the city, Bluetooth wireless
networks belonging to private homes and businesses
and commercially provided mobile phones create a
complex network of invisible electronic traffic. This is
a parallel layer of reality that although unseen is
responsible for an increasing proportion of everyday
commercial and personal transactions. Open source
movements have tried to plot these hidden wireless
resources and there are websites that show the location
of free wireless access to the Internet in every city.

The visitor as participant

There are a number of stages in becoming familiar with
works of art. There is the initial exposure to the work.
Following this there is a stage of discovery where
different characteristics are explored, and a final stage
of acceptance and familiarity.

Hidden data sources assist the artist to extend the time
the viewer spends in the period of discovery in relation
to their work. This is because the work may or may not
follow set rules in response to auditory, locative or
haptic data from the viewer. The artist may take delight
in ensuring that the work never responds in the same
way. This will mean that it will be different with each
encounter.

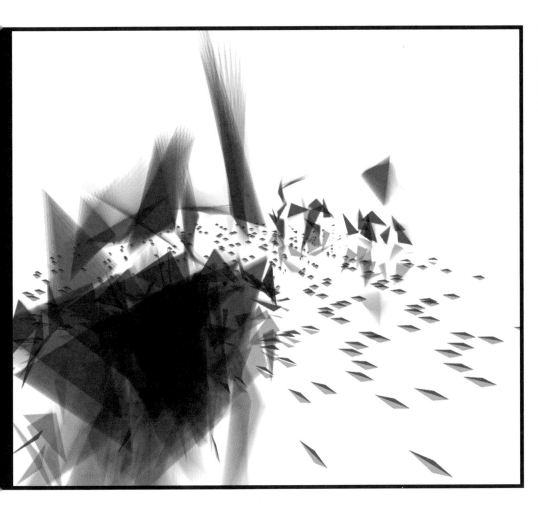

KB Knowledge Bank

1. For more information on Professor Warwick (p.78) at the University of Reading see www.cyber.reading.ac.uk/ people/K.Warwick.htm

2. For more information on I–DAT (p.79), see www.i-dat.org/ go/home

3. For more information on Sloth–bot (p.79) see www.arch-os.com/projects/slothbots.html

4. Bluetooth (p.80) technology is how mobile phones, computers, and personal digital assistants (PDAs), not to mention a broad selection of other devices, can be easily interconnected using a short-range wireless connection. See www.bluetooth.com/bluetooth/ for more information.

"The body of the public and the performer is now engaged in the creative generation of data in a variety of environments and interactive installations enabling exploration of the future potential of the human body to control and influence data."

Bodydataspace from the NODE.London catalogue

The Internet as a collaboration arena

With blogs, dynamic web pages, Flickr, mySpace, online gaming, online gambling, youTube and other user-oriented content facilities, websurfing is no longer designed to be a passive activity where content is consumed in a top-down, author/reader kind of relationship. Websites are now only considered successful if they can induce visitors to create their own content and then upload it so that this then becomes the driver of further traffic to the site.

Artists have highlighted the potential of this collaboration by engineering situations where site visitors create the work themselves. The artist's role moves towards being less of an originator of the work and more a facilitator of the creative action of others. As Paul B Davis points out:

'collaboration, communication, remixability...these are the operative words that describe Web 2.0 interactions. These interactions are a sort of meta-level complement to current information infrastructure, and they have the potential to be equally comfortable at home, in public space or in a gallery.'

The fundamentals of digital art Data into art

←
Glyphiti
Andy Deck, 2006
'Glyphiti is an online collaborative drawing project. A large-scale projection forms an evolving graffiti wall and visitors to the space are invited to edit and add graphical units or "glyphs", which compose the image in real time.'
(from www.nodel.org)

Collective image banks

Websites such as Flickr help to focus on the fact that 'hunter gatherers' are using the Internet. Not now in the sense of a search for food, but via the World Wide Web it is possible to gather images from far and wide and to sift them for resonance, reassurance or confirmation of the accuracy of a memory. The appetite amongst Internet surfers for them is endless. And as in the natural world, this gathering activity is not traceless, it has a flavour that is marked by a scent and this is left as evidence of the surfer's personal traits and propensities.

The worrying appearance of a list of one individual's Google search topics on a website serves as a reminder (if any were needed) that a network can carry information in two directions. Think hard before pressing the Enter key!

The images themselves are also prepared in a particular way so that they can take their place on the Internet as part of a massive collective memory. This is usually done by giving them a name or description (a tag that is part of the image's metadata). These tags are searchable so that images of a particular person or place will appear in response to a search. This potential for image categorisation can be used for allusion, irony, metaphor and poetry in the way in which images are handled on the Web. Word definitions in one culture can be very different in another. Double meanings and word play in picture tags bring in the possibility of extraordinarily random juxtapositions of imagery.

KB Knowledge Bank

1. Blog (p.82) shortened form of 'Weblog', an online diary including images and text that also allows readers to post comments in response to items.

2. Flickr (p.82) is an online facility for uploading and sharing images on the Web. See www.flickr.com

3. Paul B Davis (p.82) is an American artist and lecturer, see www.beigerecords.com

4. For more information on Andy Deck (p.83) see www.artcontext.net or http://www.andyland.net

5. For more information on Tom Corby (p.83) see www.reconnoitre.net/

6. Tags (p.83) a word or phrase that is attached to an image as part of its metadata.

7. (Image) Metadata (p.83) embedded descriptions of an image. These are normally unseen.

"The Internet has hugely amplified the scope and frequency of social contact and thus provided a fertile platform for mass participation and the development of new cultural forms."

Tom Corby

Narratives and the database

By embedding active links, texts become <u>hypertext</u> and the reader can decide whether or not to follow such links or stay with the original document. Each link is equally insistent in suggesting itself as the most important source of additional illumination to the text under review, but the reader can decide whether or not this is in fact the case. The hierarchical structure based on a set beginning, middle and end with each of these determined by the authoritative voice of the author is threatened by a new kind of paradigm.

Narrative relies on structure and the sequential development of a plot. Knowledge of the characters involved is built up as the author places them in a sequence of different situations. Their power as characters is dependent on the author's ability to convince of the authenticity of their words and actions within the world of the constructed narrative. As the narrative develops, the viewer or reader is able to refer back to their own memories of the previous incidents in the story. This store of memory enlarges in the mind of the reader as the story progresses, and creates a mental geography of the narrative onto which new events can be mapped and cross-referenced. Film narrative often utilises a similar method.

→
Soft Cinema
<u>Lev Manovich</u> and
Andreas Kratky
Soft Cinema has sought to open up discussion about narrative structure. Each separate incident in a story is held on a database and becomes the raw material of a limitless number of possible 'films'. Manovich collaborated with Andreas Kratky and the work exists as a DVD project, published by MIT. It has exhibited at a number of museums, including the <u>Baltic Centre for Contemporary Art</u> in the UK and <u>ZKM</u> in Germany.

TEXAS_02.txt

" The structures of ideas are not sequential. "

Ted Nelson

She was passing time by counting the passing

Reader defined narrative structures

Every narrative works as a result of an agreement between the author and the audience in a temporary suspension of judgement that allows just enough space for the different elements in the process to begin to play the role mapped out for them. The audience makes an enormous imaginative leap to fill in any gaps in the material available.

David Blair's Waxweb site was one of the first Internet sites to offer the visitor a way of constructing their own version of one of his films using what was almost a scratch video facility. The emphasis in his case was more on image-based narratives.

A narrative is a kind of prism that alters as it is turned to allow light to enter it from different angles. This perhaps explains why young children wish to hear the same story many times over even though they are familiar with the eventual outcome of the plot. A story allows the reader to imagine different endings and keeps them asking the question: 'What would happen if...?'

Digital artists have worked with this conditional aspect of narrative structure, with access to narrative elements radicalised by non-linear data retrieval systems that enable a variety of interventions to impinge on the order in which episodes are presented. Examples include response to location through GPS, random values and selection from options.

Mindtracker (opposite page) provided video sequences of 12 locations in London that the viewer could visit. They could choose to select a snapshot of each of the 12 places that would be collected to linger on as a reminder of what had been seen. Gradually a collective memory repository was filled giving fleeting glimpses into this recent past.

↑
Oral Tradition
(part of NODE.London)
Kevin Carter, 2006
This reduced the apparatus of narrative to only three elements. Two pairs of eyes, their expression made from a small selection of animated sequences. A spoken rendition of a small number of sentences taken from a popular song involving a conversation. A perpetually changing order of the sound and animated sequences. The viewer could not predict the order of the sentences and therefore the direction the story would take. The piece played on the viewer's need to imagine and make sense of the limited materials with which they were presented.

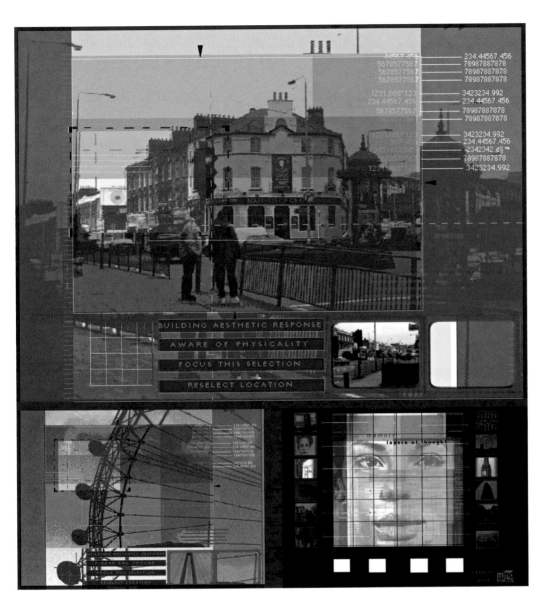

Mindtracker CD-ROM
Screen Shots
Richard Colson, 2000
Top: New Cross, London
Bottom left: The London
Eye
Bottom right: Mindtracker
Interface Screen
Narrative incident can
act as a trigger to release
other memories by
association, and it was
this that was behind the
development of
Mindtracker. Particular
geographical locations
and landscape act on the
memory in powerful ways.
Seemingly forgotten
feelings can come flooding
back to consciousness
when visiting places
known in childhood.

1. Hypertext (p.84) documents that
 branch or perform on request.

2. For more information on the Lev
 Manovich (p.84) Soft Cinema,
 see www.manovich.net/
 softcinemadomain/index.htm

3. For more information on the
 Baltic Centre for
 Contemporary Art (p.84) see
 www.balticmill.com

4. For more information on
 ZKM (p.84), Karlsruhe, Germany,
 Center for Art and Media, see
 www.on1.zkm.de/zkm/e

5. David Blair's Waxweb (p.86) is
 one of the first Internet sites to
 encourage visitors to
 reconfigure narrative structure
 for themselves. For details see
 www.waxweb.org

6. For more information on NODE,
 London (p.86), visit
 www.node1.org

Narratives and the database 087

Comparing human and computer vision

Purves and Lotto's (2003) research into human vision has provided a body of very clear evidence supporting their theory that the human visual system is characterised by active response to visual data. This is in contrast to the view that it operates simply as a passive receptor to external stimulus.

The physiology of human vision is still very much a subject for theory and counter theory and even those with many years experience at the forefront of cognitive neuroscience admit that much remains to be explained.

From the point of view of the visual arts, Dr John Tchalenko's important research project, 'How Do You Look?', has studied the involuntary eye movements that occur as an artist observes a model in the process of creating a drawing. His team used pupil movement tracking equipment to create visual records of these saccadic eye movements as the artist proceeded to draw.

Purves and Lotto have shown how these kind of movements occur when the eye is presented with anything that it can't immediately identify or where there is a certain visual ambiguity.

The digital artist and the science of human vision

Digital artists can learn much from the approach of scientists as they put forward new theories and then prepare and implement painstaking field studies to collect supporting data. In much the same way as artists, scientists often need to change direction in their thinking in response to unexpected outcomes from such studies.

←

MRI and PET Scans
Wellcome Department of Imaging Neuroscience, University College, London. In order to explore current thinking about human vision, I contacted the Institute and assisted in a research project there. My brain was scanned by an MRI system at the unit and the resulting image file provided fascinating 3D views of the visual system, including the eye, the optic nerve and the primary visual cortex. I also underwent a PET scan designed to assist with the identification of areas of brain activity that occur in response to a particular kinds of questions concerning visual stimuli.

❝Therefore any general theory of vision must deal with changing spatial relationships and the sensations of motion that are usually, but not always, elicited by the ensuing sequence of images.❝

Purves and Beau Lotto

Digital art as a response to science

Data collection and its analysis is normally pursued with a scientific aim in view. The scientist may have a theorem that will only stand up to the scrutiny of the scientific community once it can be presented in the context of statistics derived from such data. Loc Reverb was developed against a context loosely defined by scientific methodologies.

Loc Reverb is an installation and a CD-ROM. It is an attempt to provide a dynamic non-scientific simulation of the way in which the human visual system deals with a landscape. It tries to show dynamically the mechanisms for analysing visual phenomena; the methods used for comparing memories in both short and long term memory; the movements of the eye as it scans up, down, left and right across a scene, and the processes by which the eye estimates distances and visual relationships between features of the landscape.

Loc Reverb responds to movements of the trackball to create a series of horizontal and vertical grid lines across the moving background image and these redefine their own position and motion. These lines combine with transparent gradations that interfere with a reading of the image and provide a metaphor for the way in which human visual perception needs constant revision as it is confronted by contrasting glimpses from different parts of the scene.

The piece is designed to illustrate the perceptual accuracy and recognition of precise detail in vision and the way the viewer also has a simultaneous sense of the whole and the expanse of space on a much broader scale. The desire to measure and record is contrasted with the impulse to scan across the view with one sweeping movement of the eye.

Computer vision

Any computer can be programmed to 'see' by processing images using algorithms that are designed to look for particular kinds of information and also by comparing differences that occur in images presented for analysis one after the other. This is a highly specialised branch of computer science.

Computer vision requires rapid simultaneous processing of a variety of data incorporating:

1. Colour analysis, which assists with object recognition and tracking.

2. Analysis of light fall, which provides information about physical distances between objects.

3. Application of geometrical formulas, which results in the necessary calculation of changes in location within a room (useful for robot vision).

4. Edge detection, for differentiating between different objects in a scene.

5. Range finding, for calculating proximity.

Programs designed to deal with these kinds of phenomena are required to compare video images in quick succession to establish similarities and differences as a basis for further calculation.

KB Knowledge Bank

1. For more information on Purves and Lotto (p.88), read Purves, Dale and Beau Lotto, R., 'Why We See What We Do'(Sinauer, 2003), or see www.purveslab.net/seeforyourself

2. For more information on Dr John Tchalenko (p.88), see www.arts.ac.uk/research/17487.htm

3. MRI (p.89) a Magnetic Resonance Imaging scan.

4. PET (p.89) a Positron Emission Tomography scan.

↑
Loc Reverb
Richard Colson, 2003
Exhibited at Deluxe Arts
Gallery, London, in 2003
(Part of Site Soundings
+ Digital Terrains), Loc
Reverb presents a world
that is never still, never
the same and always
in-between two states,
always being revised and
always provisional. It
attempts to come close
to the experience of
conscious perception.

"Yet this philosophy still to be done is that which
animates the painter – not when he expresses his
opinions about the world but in that instant when his
vision becomes gesture, when, in Cézanne's words he
'thinks in painting'."

Maurice Merleau-Ponty

4 Creative priorities for coding

Not everyone wants to be a programmer but it is still important to know about changes to programming methods that have been going on in the last few years. These changes are putting sophisticated programming techniques within the reach of even the most hardened programming refusenik! In this chapter we will examine what has been happening.

Finding a heart in the code

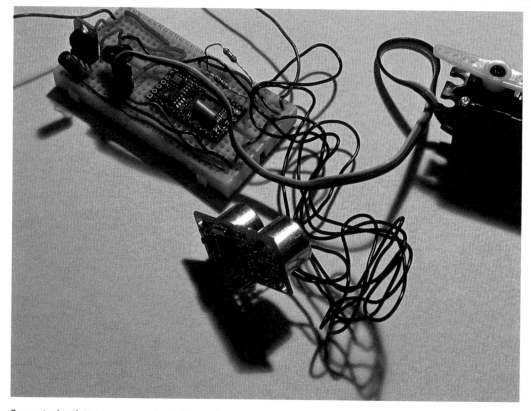

←
BX-24 Micro controller with SRF-08 Ultrasonic sensor and servo motor
This motor's movement depends on the distance of an object from the sensor. The preparatory sketches and studies of artists using electronics may not be recognised for what they are. They will be part of a circuit with trials to test out the practicality of combining two components for the first time. There will be wire tangled in different directions before the discipline required for building a prototype imposes more order.

Conceptual artists are concerned with ideas rather than form. Their practice develops in a way that is not confined by the properties of particular substances or media. In a sense, ideas are their form and have taken on the same malleability of clay or paint. The stages of modification and refinement that can be seen in sketches, maquettes, small-scale studies and other preparatory work all happen in the mind for these artists and are not for public view. However, they are still as crucial a part of their practice as they are for painters and sculptors. Their chosen medium plays the central role in determining the final format of their work.

```
Processing - 0115 Beta
File  Edit  Sketch  Tools  Help

object_imagebitsworkswithsensor22
// Uses the first available port
port = new Serial(this, Serial.list()[0], 19200);
size(2000, 1800);
background(255);
noStroke();
framerate(60);

  j=1;
    a=0;

num = 1600;
mods = new Module[num];

  for (int i=0; i<1600; i++) {
      num2=i;
      if (j>1900){
      j=0;

      }
      j=j+1;
      if (a>2500) {
        a=0;
        }
      a=a+45;
      mods[i] = new Module(100,num2,j,a);
    }
  }
void captureEvent(Capture camera)
{
  //Scamera.read();
```

↑
Processing sketch showing a loop statement
Artists who rely on computer programs to create their work also create preparatory work and sketches. Their medium consists of loops, conditional statements, real numbers and integers and their sketches might be program printouts. In the 1970s, this would have been in the form of punch cards that were the only method around for giving the computer instructions.

Code as a medium

Initially, any experience with programming tends to be characterised by frustration, confusion and amazement at the amount of time required to achieve very little. But alongside this there is a growing recognition of the scale of the work behind a program such as Adobe Photoshop or Illustrator. With the necessary assistance, there is the second stage where confidence and a sense of achievement provide the impetus to make further progress and discovery. To go further with the medium artists have to move to a point where they begin to appreciate the elegance of the coding structure, the precision required in writing statements and the flexibility available for posing problems and finding solutions.

At this point programming has become a medium for the artist. It ceases to act to restrict idea development but allows artists to harness the processing power of the computer in order to achieve their aims. Just as with any other medium, the chosen media begins to influence not only the working methods but also the final form the work itself. The medium provides the artist with a different register of sonority and texture, extending their palette of options in certain specific directions.

It could be said that from now on the code almost has a heart. It is no longer unwieldy, difficult and mystifying. Instead it offers its own responses and suggestions in a creative partnership with the artist.

❝Programmers write – not 'sequences' [of instructions] – but specifications for the individuals of little societies. Try as he may he will often be unable to envision in advance all the details of their interactions. For that after all is why he needs the computer.❞

Marvin Minsky

→

Artport: The Whitney Museum Portal to Net Art

In 2002, Christiane Paul (the New Media Curator, Whitney Museum of American Art) curated CODeDOC, an exhibition held at the Whitney Museum of American Art, New York, where contributing artists were asked to submit their work and the programs used to create it.

Artists worked with Java, C++, Visual Basic, Perl, and Lingo. Looking at the code while the pieces were running, your attention would be drawn first to one and then to the other as the actual implementations showed the coding instructions becoming a reality. In the gallery and online, the visitor could swap from one to the other to try to build a meaningful relationship between them.

Musical notation has the same quality. Looking at the crotchets and quavers on the page does not equate with the beautiful sound of the violin playing the notes, but one could not happen without the other. This relationship between the actual written code and its results could form the basis of work that tries to own its origins in a more transparent way.

WHITNEY **artport** THE WHITNEY MUSEUM PORTAL TO NET ART

sponsored by **hp** invent

GATE PAGES | COMMISSIONS | EXHIBITIONS | RESOURCES | COLLECTION | ABOUT ARTPORT

Commissions

CODeDOC

Launched September, 2002

A second installment of CODeDOC with eight additional artists was commissioned by Ars Electronica for the 2003 Ars Electronica Festival "CODE -- The Language of our Time." CODeDOC II launched on September 6, 2003: www.aec.at/CODeDOCII.

| Golan Levin Java | Mark Napier Java | Brad Paley Java | Scott Snibbe Java | Martin Wattenberg Java | Maciej Wisniewski Java | John Klima Visual Basic | Camille Utterback C | Mary Flanagan Lingo | Kevin McCoy Lingo | Sawad Brooks Perl | Alex Galloway Perl / Text |

Code to do what?

Code is written to do certain things. Software writers are all concentrated on creating products that are as intuitive as possible for the user. They want to write code that is totally discreet, an invisible element behind the simplicity of the interface.

Beginning to write code forces a realisation that everything visible on the computer screen has been made by a statement in a computer program. The colour of the screen, the size of typeface or the shape of the cursor: each of these is addressable using code. Everything that the computer does can be controlled. Most commercial software on the computer does not allow this kind of access to the system and therefore prevents certain creative possibilities. The aims of commercial software developers are weighted towards the largest user base and this tends to be those working for clients in the commercial sector rather than independent artists.

As a result it is the artist who is prepared to work without this software who will be more likely to find ways of working with the actual components of the computer system as a normal part of their practice. For example, their work may be concerned with: 2D and 3D graphics; image processing from video; communication with devices connected locally to the computer or information communication across the Internet or LAN.

KB Knowledge Bank

1. For more information on Artport (p.96) see www.artport.whitney. org/exhibitions/past-exhibitions.html

❝Some day artists will work with capacitors, resistors and semiconductors as they work today with brushes, violins and junk.❞

Nam June Paik

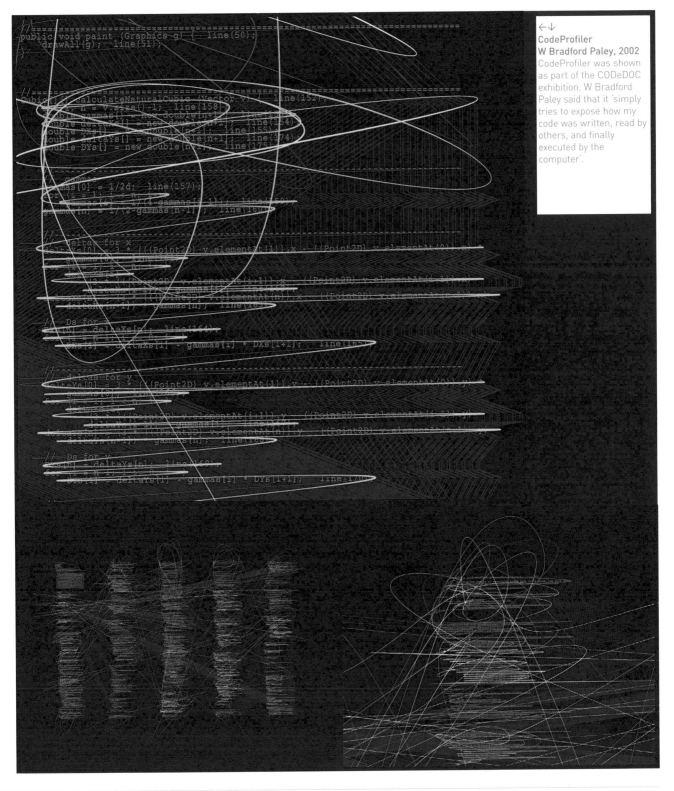

←↓
CodeProfiler
W Bradford Paley, 2002
CodeProfiler was shown
as part of the CODeDOC
exhibition. W Bradford
Paley said that it 'simply
tries to expose how my
code was written, read by
others, and finally
executed by the
computer'.

New programming tools

A number of options are available to the artist who wishes to develop a practice using coding methods. In the 1960s and 1970s, artists had no choice but to learn machine code language such as Assembler, for example, as there were no programs available to provide the necessary translation from English sentences to the 1s and 0s understood by the computer.

This is no longer necessary, and programs such as C++ or Java have compilers to do this. C++ and Java are still difficult to learn and it is unwise to believe the marketing hype that insists that they can be learned in 21 days. But assuming there is sufficient time, knowing one of these programs should open up enormous creative potential for the artist.

Processing

However, for those who might find this prospect daunting, Casey Rees and Ben Fry have provided a program called Processing that takes out some of the sting of learning a full-blown grown-up language such as Java or C++. They have provided an instruction set that uses the Java compiler, but does not require such an in-depth knowledge of the Java language. Processing is an open source programming language and environment for people who want to program images, animation, and sound. It is no exaggeration to say this initiative has put a different sort of heart in the code – providing artists with an arena for support, inspiration and discussion.

The program can be downloaded free of charge. Example codes help artists to start working immediately and they are soon producing their own programs and returning to share their own results with the community.

↑
Fortran IV punch cards
Fortran programmers prepared their stack of cards ready to be read by the computer. If there was a mistake, all of them would have to be read in again.

Collaborative enterprise

It would be difficult for a sculptor or a painter to collaborate with others to produce one of their works. The sculptor is not able to send a lump of clay across the world in order to request assistance with a particularly demanding aspect of modelling. A canvas cannot be couriered from one studio to another to allow painters in different places to retouch a delicate series of glazes in the picture.

By contrast, the programmer's medium can very often be reduced to text, and so is easily sent from one computer to another no matter where the location. Sculptors and painters are always learning new things about their chosen medium but it is rare to find them sharing the findings in a way that is fairly common among artists using code. Artists using programming need to communicate with others as part of their learning process and the World Wide Web facilitates in the development of this creative community.

Originality is a crucial factor in the artistic process and artists such as Leonardo da Vinci even went so far as to write all their findings using a mirror so that the contents seemed indecipherable to the casual visitor leafing through his papers.

The more open practice among digital artists is partly engendered by the use of the Internet itself, which encourages discussion and the sharing of knowledge. These artists have also experienced the benefits that accrue as their code is used by others, extended and then returned to them with all sorts of new possibilities and improvements they had not seen themselves.

↑
www.processing.org
This is an open source project and has generated enormous interest from artists around the world. The user community exchanges code and ideas within the website's forum and tackles creative problems together.

Knowledge Bank

1. C++ (p.98) developed by Bjarne Stroustrup, this program (originally named 'C with Classes') in 1983 as an enhancement to the C programming language

2. Java (p.98) is a computer programming language developed by Sun Microsystems (see www.java.com)

3. Processing (p.98) is an open source program developed by Ben Fry and Casey Rees (see www.processing.org)

↑
Manifest
Michael Chang, 2005
'Manifest' was made using Processing. In this program new creatures are created by mouse movements. Their size and behaviour are dependent on the length of time that the mouse is kept pressed down as it is moved across the screen

Relinquishing creative control

↑
Still from play-create.com
Daniel Brown
Courtesy Daniel Brown
This is an example where
the artist has established
particular parameters.
Within them, the program
then has complete
freedom to produce any
number of variations or
mutations.

The fundamentals of digital art Creative priorities for coding

It is important to look closely at the possibility of using some kind of non-sequential or <u>random working</u> process. The artist working in this way takes a deliberate decision not to exercise conscious control at certain points as a work develops.

Computer programming offers a real opportunity to bring unlimited processing power to bear on the possibility of introducing images that are the result of a set of unplanned instructions.

The programmer can hand over to the computer a set of rules that can become steadily more and more degraded and alter the work to the point where all control is lost.

↑
Printed output from
Graphical Mess (top) and
Graphical Mess (bottom)
Seth Beer, 2006
A radio-controlled printer
leaves a gathering
complexity of images
superimposed one on the
other. The artist facilitates
image development, but
has no control over what
is produced.

Random working methods

Leonardo da Vinci used to recommend that young painters draw old textured walls as a means of finding a fruitful starting point for a new composition. In a similar vein, Max Ernst's <u>Frottage</u> technique (1925) involved taking rubbings of a series of different textured surfaces. Both artists were trying to give themselves a jolt, a visual surprise that would force them into new creative territory. The results were strange juxtapositions, outlandish treatments of accepted symbols and random patterns.

Following the publication of Sigmund Freud's 'The Interpretation of Dreams' in 1911, artists began studying aspects of experience that seemed to provide a direct route through to the unconscious. The drawings of children or the work resulting from psychoanalysis seemed to have a lack of inhibition and immediacy of vision that artists wanted to recreate.

Computers offer access to data that does not have to be sequential. It too can be random. Digital artists need to negotiate with delicacy the boundary between the logical methodologies that are part of the way they have to work and their undefined artistic intentions, which sometimes require withdrawal of conscious control in order to be really compelling. Their work is often tipped more one way than the other but when evenly balanced, these two elements can result in work that is tense and exciting.

To knowingly relinquish control is almost a contradiction. To be out-of-control means to stop taking decisions based on a logical assessment of what is happening. But artists need to be able to move between control and chaos in a way that is going to give them the best opportunity of using what both have to offer their practice.

The fundamentals of digital art Creative priorities for coding

A computer program can be asked to calculate a random value between a range of numbers. This value can be used to select information from a list of images, sounds, text or devices. The resulting values can control the position of an image on-screen, how it appears, the time that it is on the screen, its transparency or distance from the viewer. Any aspect of the information that requires a numerical value can be controlled by the random value number the program has been asked to generate.

KB Knowledge Bank

1. Random working (p.101) is done or made at hazard, or without settled direction, aim, or purpose; hazarded without previous calculation.

2. Frottage (p.102) is a Surrealist automatist technique developed by Max Ernst in drawings made from 1925.

↑
Nature
John Maeda, 2005
The Nature series consist of seven motion paintings representing abstract forms in movement that recall natural phenomena. Maeda set up the rules but has no control over the final result. Taking his metaphors from nature – trees, sky, grass, moon, rain, snow – Maeda offers us a glimpse of digital space in the spirit of landscape painting.

Object-oriented programming

↑
Fly objects
These fly objects were created in Lingo with Macromedia Director. The flies are created automatically every two seconds until the maximum number is reached (100).

↓
Boat objects
In this simple example, created in Macromedia Flash ActionScript and Processing, the objects have a lifespan of 20 seconds. Text showing position values and remaining length of life are constantly updated.

Object-oriented programming is a flexible, re-usable, modular programming paradigm. The individuals based on the pattern are objects. In programming terminology, these individuals are known as instances of the 'class'.

Why is this sort of approach worth spending time on? Is it that the artist needs to feel in control of things as a way of massaging their ego? In fact the opposite is the case. These individual units can have an inbuilt independence that develops over time and this can mean that they are acting in ways that the artist never imagined and certainly has no control over.

Digital artists want to engineer situations where these instances can develop in a free and unhindered fashion.

KB Knowledge Bank

1. Object (p.104) is another word for the individual instance made from the class.

2. Class (p.104) is a key aspect of object-oriented programming. New instances are made by a call to a particular class e.g. the fly class.

3. Adobe Macromedia Director (p.104) no longer has the user base it enjoyed in the past but still retains some of its popularity. For more information see www.adobe.com/products /director

4. Adobe Micromedia Flash (p.104) is the most widely used tool for developing web content. For more information see www.adobe.com/products /flash/flashpro

5. Variables (p.105) are values that can be changed.

6. Properties (p.105) are another kind of adjustable values.

7. Instance variables (p.105) are adjustable values associated with a particular instance.

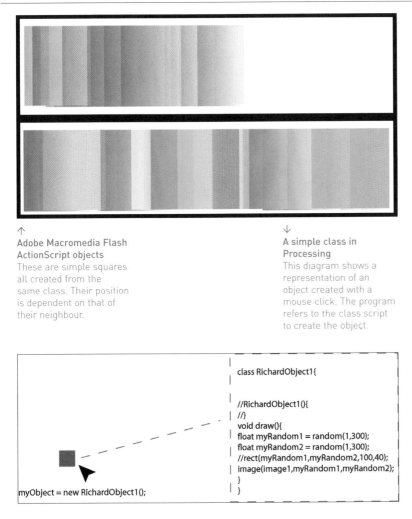

↑
**Adobe Macromedia Flash
ActionScript objects**
These are simple squares
all created from the
same class. Their position
is dependent on that of
their neighbour.

↓
**A simple class in
Processing**
This diagram shows a
representation of an
object created with a
mouse click. The program
refers to the class script
to create the object.

```
                              |   class RichardObject1{
                              |
                              |   //RichardObject1(){
                              |   //}
                              |   void draw(){
                              |   float myRandom1 = random(1,300);
                              |   float myRandom2 = random(1,300);
                              |   //rect(myRandom1,myRandom2,100,40);
                              |   image(image1,myRandom1,myRandom2);
                              |   }
myObject = new RichardObject1();   |   }
```

Properties and behaviours

To better understand class and object, perhaps it would
be clearer to think of a specific example. In the case of
a fly moving around a computer screen, there would be
a minimum number of actions the fly would have to
make in order to be partially convincing as a live
insect. It would have to fly in haphazard ways. It would
have to settle and preen itself, perhaps eat something
when it came across meat and it would have to walk
along the ground to left or right sometimes emitting a
buzzing sound.

In the prototype of the fly or the fly class, all these
aspects could be planned so that it would be important
to ensure that the time it spent on each action could be
adjustable and so would seem to be initiated
independently by the fly itself.

The second key concept comes in here, variables. The
mould remains the same for each individual created
from it but there are attributes that are customisable for
each one. In the case of each fly, there might be a
different sound, there might be a selection of styles for
the wings or the abdomen and this would provide the
necessary variety.

Each of these characteristics is determined by
properties or instance variables, for example: lifespan,
speed of walk, appearance, size or duration of preening
behaviour. Some of these will be common for flies and
some will only apply to one of two individuals.

This unique set of rules governing the fly's behaviour is
controlled by the customisable properties mentioned
earlier. These are empty values of the class and they are
waiting to be defined as part of the process of creating
the individual flies from the pattern. Programmers give
the names such as Plifespan or Ppreeningtime. This
convention of naming allows someone else to quickly
understand the script and see what kind of value it
refers to.

❝A program grows in power by an evolution of partially understood
patches and fixes...[the programmer]...begins to hope instead of know,
and watches the results as though the program were an individual
whose range of behaviours [are] uncertain.❞

Joseph Weizenbaum

Hierarchies

In object-oriented programming, the birth of an object marks its starting point, the moment it comes into existence. The key word for programming objects is 'new' and it is used as part of the syntax for creating an individual object instance from the class. The fly class that we saw in the last section can be called on any number of times to create a new fly object with its own set of attributes.

The flies will have some of these attributes in common and some will be unique to the individual instances. For example, all the eyes and abdomens could be defined so that they are all the same, but we could have a wing class that works as a subclass of the fly and this would mean that the wings could have different colours or transparency values.

In creative terms, imagine suddenly that the shapes of all the abdomens had to be changed. With this way of working only one part of the program, the fly class, would have to be altered — the wing class and any other subclass would still remain the same and be added to the adjusted abdomen size.

↑
Form Synth
William Latham, 1985
Image supplied courtesy of the artist
William Latham discovered a method of quickly changing the parameters that governed the development of a 3D form or creature.

This hand drawing demonstrates his interest in hierarchical structures. This was produced some time before the 3D forms that are the hallmark of his later work.

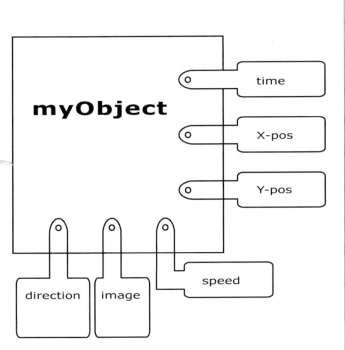

↑
Diagram of class hierarchies in programming
The object is shown with tabs representing variables. These control its lifespan, its position, the direction it is travelling, its speed and what it looks like.

↑
Lifecycle of an object
With every object that is created from the class there are stages in its development from its starting point through to the end of its existence.

Birth: Its initial state is defined; how big it is, where it is and its properties are established.
Phase 1: Development period, location, energy levels.
Phase 2: Its characteristics change in response to proximity of other objects, environmental factors.
Phase 3: Birth of sub-objects, parasitic behaviour of sub-objects.
Phase 4: Decline of faculties of the object and its ability to ward off predators, reduced energy levels.
Phase 5: End of object's life, decay and death.

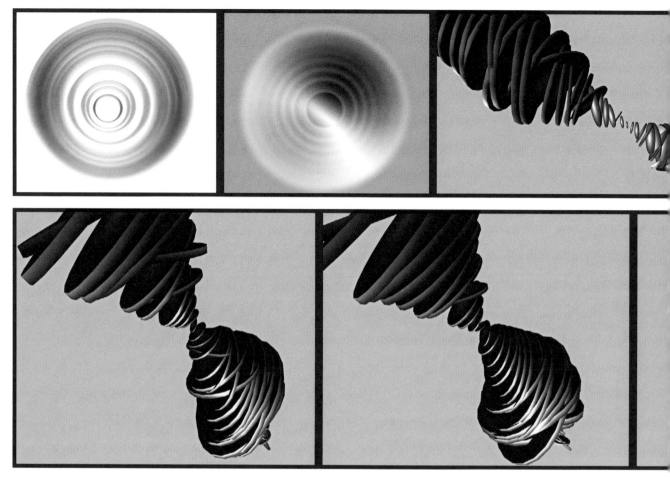

Family likeness?

Another way of thinking about hierarchies is in terms of parents and children. Children take on some of the characteristics of their parents but also have their own individual features that they have not inherited from the parental generation.

This way of working allows digital artists to create programs that are:

1. Extendable: more detail can be added to the same basic element.

2. Flexible: all attributes of the flies can be adjusted by making one alteration.

3. Reusable: the same code to create flies could be changed to create birds or wasps.

4. Open: nothing is set in stone and by leaving helpful comments as the program is written others could have an input into what is happening.

Of course it might seem easier not to have to think in these terms. It certainly is a challenge to write object-based code and when solving some intricate problem, it sometimes can seem very unrelated to the original artistic impulse. Digital artists have to be prepared for such periods in their development. Such times can seem rather arid in themselves but are necessary if longer-term goals are going to be achieved.

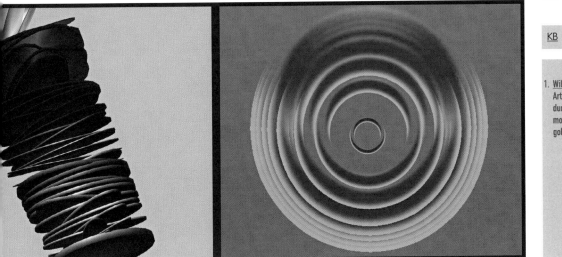

←
Relational Dependence
Richard Colson, 2003
Clockwise from top left:
Mud Circles, Tornado I,
Relational Bars I,
Relational Bars II, Ripples,
Tornado II, Tornado III and
Tornado IV
The same approach has
been used in both 2D
and 3D imaging. In these
examples, the various
elements use the size
and position of their
neighbour to determine
their own attributes.

KB Knowledge Bank

1. William Latham (p.106) was
 Artist in Residence at IBM
 during the 1980s and 1990s. For
 more information see www.doc.
 gold.ac.uk/~mas01whl/

Grouping objects together

Returning to the fly class example, in order to create a
group of buzzing flies, I would need to use an iteration
process. This means calling on the fly class to create
a new fly a certain number of times e.g. 100. This is
fine and would be an acceptable method of providing
100 fly objects.

More sensible, however, would be to put these flies into
an array or list as soon as they are born (e.g. Flyobject
1, Flyobject 2, Flyobject 3 and so on). This would have
the advantage of allowing another part of the program
to run any update routines or to keep an eye on what
was happening to them.

An array would list the objects and allow access to them
so that their appearance, speed, position, lifespan or
any other aspect could be controlled and altered.

This also opens the possibility of using the current value
of one of them as a way of determining the one next
to it. If each was to follow the one before, the program
could look at the position values and then add a
value to create an interval between. Replace this with
the random value and some really interesting
possibilities emerge.

❝Programming is the process of
abstracting a graphic form into its
fundamental geometrical components.❞

John Maeda

Computer principles for artists

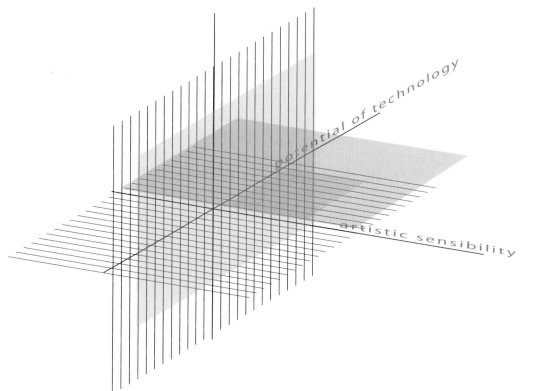

potential of technology

artistic sensibility

←
**The two axes of
artistic sensibility
and technological
development**
The purple area defines
the common ground
between the two axes. As
an artist finds that their
practice is further from
the centre down one axis
or the other, the chance of
successful overlap
decreases.

**Arthur Koestler develops his notion of bisociation as a
way of explaining the truly creative and original act. He
shows how knowledge or skills gained in two
completely separate areas of experience can be
mapped onto each other in the mind and can result in
radically new approaches and solutions.**

In rather simplified terms technological change and
development could be seen as forming one axis of
possibility of engagement for the creative mind. Another
important axis might be that of the artistic sensibility.

A coordinate system based on these axes could be used
to begin to map new sorts of creative territory that draw
from an understanding gained in each area. Artists
grapple to try to mesh one with the other to move
towards a place where they can make artistic sense of
the potential presented by innovations in products and
services. This goes with the territory for creative digital
artists. The knowledge base with which they work is
expanding all the time and in some ways results in a
synergy from which their work gains extra momentum.

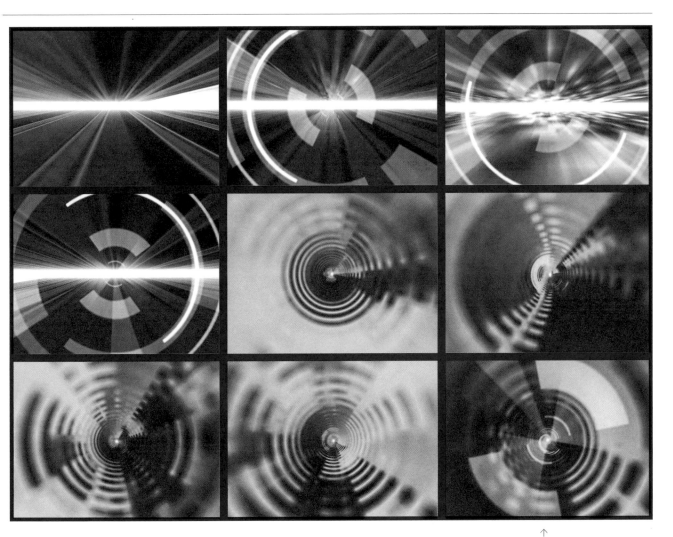

↑
**Stills from Digital Hustle
Susumu Asano, 2006**
Thes stills are time-based
sequence combined live
action video with post
production special effects.
This kind of visual rhythm
and syncopation is
something that can only
be learned by direct
experience of time-based
media.

**"To me the neutrality of the machine is of
great importance."**

Marc Adrian, 'Cybernetic Serendipity', Studio Vista Special Issue, 1968

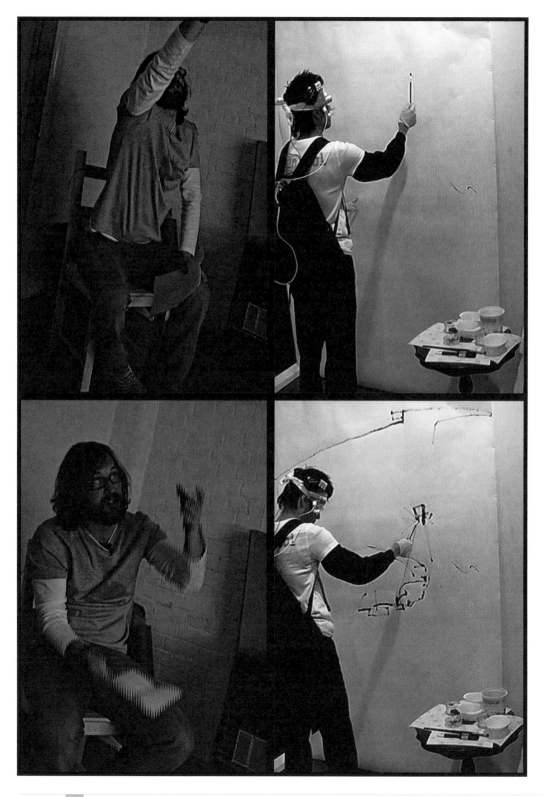

←
Human Tool
Lukas Birk, 2006
The 'human tool' is
instructed in the same
way as an avatar in a
console game, but with
exclusively artistic
intentionality.

Innovation

Keeping abreast of innovation: this is not done because innovation is considered to have an innate value, but so that any potential can be quickly assessed for artistic significance.

Including innovation within the scope of the artistic goals and exploration.

Discussing innovation with those whose aims are not centred exclusively on commercial products or services.

Providing access for others to this kind of innovation – 'play' areas so that a wider user base can have an influence such as <u>Sodaplay.com</u> or <u>Mongrel</u>, for instance.

Working Methods

Identify, name and classify the impetus for the creative impulse.

Establish working methods that are informed by the medium itself and an understanding of what it offers.

Explore randomness as symptomatic of our time.

Be aware of bodily presence and how to utilise spatial awareness and understanding of gravity and movement.

Understand interfaces as an elision between two worlds.

> "I just know I like to play with the world. I like to have the possibility of modifying certain circumstances, certain conditions in the environment. I think artists are going to be influenced by science in one way or another and I think this is going to force some new definition of art. This is inevitable."

Charles Csuri, 'Cybernetic Serendipity', Studio Vista Special Issue, 1968

Strategies for digital creativity

Frustration – the temporary relinquishment of conscious control liberates the mind from certain well worn paths of thought. Keeping control maintains the discipline required for solving problems, but may become an impediment to the creative leap that can uncover new methods of working. This sort of leap may lead to other types of ideation springing into life resulting in what may be more instinctive and heartfelt solutions.

In the past, artists have tended to embrace technological change. Not all of them of course and with someone like William Morris and the Arts and Crafts movement in the UK we see a retrenchment, a definite decision not to utilise the potential of mechanisation.

 Knowledge Bank

1. For more information on Soda Constructor (p.113) see www.sodaplay.com

2. For more information on Mongrel (p.113) see www.mongrel.org.uk

5 Art and networks

Technological innovations and communications devices are allowing us to multi-task in unexpected ways. I can be walking in the city, have my position logged in a 3D virtual environment, talk to colleagues back at the office and receive information about where to go next to complete a task. I can leave electronic messages in a virtual model of a city using my GPS (Global Positioning System) coordinates and these can be picked up by someone else as they approach the same location later in the day. Digital art is being developed that uses this sort of possibility and we will look at the kind of work being done with location tagging and mixed-reality gaming.

Online networks

The use of online networks by digital artists requires careful consideration by curators, artists' co-operatives and galleries who wish to make this kind of work available to the public. Indeed some artists see involvement in this sort of exhibition as a surrender of the very notion of art that was the reason for their decision to use online media in the first place. Many of them are drawn to use the Web in order to gain direct access to their audience, without the mediation of the art establishment bureaucracy. As time has gone on, however, other issues have played a role in forcing some artists to reappraise the wisdom of this attitude.

For example, the gradual obsolescence of technologies used in Internet art (e.g. plugins become unavailable and browsers eventually no longer provide support for some types of content), and the need to maintain a constant process of revision in the case of older pieces, places an additional logistical burden on the artists should they not be willing to lose their online presence and profile.

Curators and galleries are also faced with the challenge of finding an acceptable means of providing offline archives of work only ever designed to be an online 'connected' experience. Artists who wish to continue to practise in this area have had to be somewhat more pragmatic. Equipment, specialist expertise and bandwidth capability all require resources and to remain outside the structures within which these might be made available may put their future programme of projects in jeopardy.

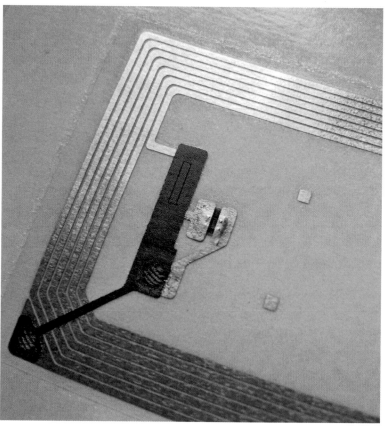

↑
RFID strip
Courtesy Kevin Bryan,
The Barcode Warehouse
A radio frequency identification (RFID) tag makes networked objects a reality. Each tagged object can be located and tracked within the designated area.

On the Net or in the Net?

Artists using the Internet are very different from those who use it only as a way of showing work created with other media. Examples of artists falling into this category are Alexei Shulgin, Andy Deck, Thomson and Craighead, Susan Collins, Heath Bunting and Graham Harwood/Mongrel. Some of these artists' work could be seen as trying to unravel the hidden assumptions that lie behind current practice on the Web.

Prominent institutions that have mounted comprehensive exhibitions of art created with online networks include: the San Francisco Museum of Modern Art, the Whitney Museum of American Art, New York, and the Walker Art Gallery in Minneapolis.

Connectedness

The discoveries that have resulted in the ability to link separate items within a network are very significant, both in terms of their immediate practical application and also because of their influence on artistic practice and thinking. In the network, a knowledge of each element is now no longer isolated but it is enhanced by an understanding about its place within a wider configuration of links and relationships.

Vanavar Bush set out just this kind of vision with his memex machine in his essay 'As We May Think' (1945). Since then the Internet and the World Wide Web have made a reality of much that he included there and an ability to connect things has become one of the defining features of contemporary life.

Ted Nelson's development of hypertext was touched on in Chapter 3 (see pages 084–087).

The writer Bruce Sterling has a wide following on the Internet as a key commentator on technological innovation. He has the knack of being able to assess how such innovation will impact on society as a whole and highlights both the resulting benefits and problems.

His current preoccupations with methods whereby every object in the world is given an IP address relates to the miniaturisation of connectivity technologies. It is bound up with his conviction that present and future ecological imperatives will dictate that RFID strips on every item will hold data about the object's manufacturing history so that its parts can be easily recycled.

Sterling's vision is for a loss of differentiation between an object and its capacity to exist online within an inventory of 'all that there is'. This will no longer be a value added marketing feature, it will be in the list of standard specifications. There will be a network linking every object.

KB Knowledge Bank

1. For more information on Alexei Shulgin (p.117) see www.desk.nl/~you/

2. For more information on Andy Deck (p.117) see www.artcontext.net

3. For more information on Thomson and Craighead (p.117) see www.thomson-craighead.net/

4. For more information on Susan Collins (p.117) see www.susan-collins.net/

5. For more information on Heath Bunting (p.117) see www.irational.org

6. For more information on Graham Harwood/Mongrel (p.117) see www.mongrel.org.uk/

7. Hypertext (p.117) a method of highlighting and linking text with additional content used within an Internet-browsing environment.

8. IP (Internet Protocol) (p.117) provides the fragmentation, routing and reassembly of data, which is the basis of online communication.

9. Radio Frequency Identification (RFID) (p.117) is an automatic identification method, relying on storing and remotely retrieving data using devices called RFID tags.

❝Another definition by contrast is that art in the Net as opposed to merely on the Net must exploit the particular qualities of hardware and software to the extent that is unthinkable without its medium the Internet.❞

Andreas Broekmann, 'Are You Online?: Presence and Participation in Network Art' in 'Prix Ars Electronica 20 Years' (ed. Timothy Druckrey)

The roaming artist

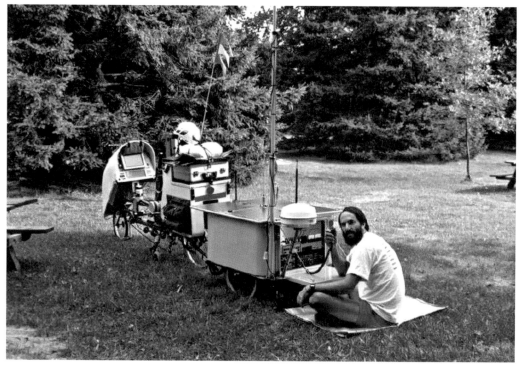

←
BEHEMOTH
Steve Roberts
Photo: Nomadic Research
During the 1980s and
1990s, Steve Roberts
completed two epic
journeys across the
USA on pedal-powered
vehicles fitted with all
the necessary equipment
for independent online
roaming.

In chapter 1, time was spent examining the way in which technological developments create unexpected spin-off benefits for the digital artist. These may be in a new wide range of different fields and will probably require them to cooperate closely with scientists and technologists responsible for such innovations.

As artists try to acquaint themselves with these new technologies, they also need to begin to fit them within a conceptual framework based on their artistic sensibilities. They still maintain a respect for the scientific goals of colleagues in the scientific community but do not need to be constrained by similar regard for logical progression from one stage to the next.

The contrasts of agenda highlighted here are particularly noticeable in the area of mobile and wireless communications. The business interests involved make any sharing of proprietary software very unlikely and in the case of the handset manufacturers and network providers, the only concern is to increase call and service volume in a highly competitive market. Sport, entertainment, gambling and celebrity news content are the services that attract the largest mainstream interest. It has proved difficult for artists to enter this arena and to make an impact (exceptions would include the-phone-book.com). Yet the mobile technologies continue to offer something that is intrinsically compelling for the imagination. Perpetual absence and presence. To be here and nowhere.

Ubiquitous and pervasive computing

One of the most compelling images of self-sufficient mobile computing is Steve Roberts's Winnebiko I and II journeys across the US in the 1980s and early 1990s. Everything required for mobile, online, freewheeling cycling was compacted onto his recumbent bike and trailer. Solar panels, satellite dishes and aerials and a specially adapted keyboard ensured he had the power and communications capability to remain constantly online as he journeyed from place to place. His machine was evidence that even at that time it was possible to radically simplify the essential components required for mobile connectivity so that they did not restrict his roaming spirit in any way at all.

The search for mobile information exchange continues today but is now pursued in high street electronics stores rather than being limited to a community of somewhat unusual pioneers like Steve Roberts. Navigation systems are now a standard feature on new cars.

Driving the interest in this capability is the quest for a multi-layered experience of individual selves. These selves are connected yet divided; they can interrelate if they wish but are separated by geographical location. One of the selves can be located using latitude and longitude and is limited by the physical body and presence but technology allows the others to have a virtual existence unfettered by any requirement of physicality.

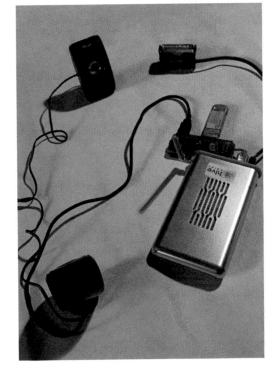

← Hivenetworks
Raylab's Hivenetworks is a radical new artist-led initiative. Director Alexei Blinov wants to 'make information processing truly accessible without usurping human space'. Raylab's aim is to develop solutions that populate urban spaces with open, mobile and flexible networks. The current solution is based on equipment that transfers and shares data on a wireless network using devices such as the ASUS WL-HDD.

The Hivenetworks system adds functionality to wireless equipment, enabling it to act as an intelligent node within a network. By changing firmware on wireless equipment, Hivenetworks adds functionality and intelligence to equipment that is normally a sleeping gateway to other devices. This can turn a wireless hard drive and disk into a small Internet server, transforming it into a battery-powered mobile device.

To create this sort of functionality in these devices currently requires considerable technical knowledge.

Hivenetworks is trying to simplify the whole process for the ordinary user and encourage adoption among the wider community.

❝It was then that it became clear to me just how much the fields of art and technology are segregated, making it difficult for those who seek to understand both.❞

John Maeda 'Maeda@media', Rizzoli, 2000

Locative media

The GPS signal from a mobile phone can be relayed to a server and take its place within a virtual representation of the surroundings where movements in the physical world can be faithfully tracked and transcribed into a simulation of real space.

The same device allows for the owner's presence to be detected by other Bluetooth or wireless networks. Personal interchanges can be initiated adding another layer of syncopated patter and social congress. Files can be exchanged and shared.

←

**Trace Encounters
Brad Paley, Peter
Kennard and Jeff Han**
Artists are interested in hidden layers of reality, particularly if nobody else has noticed them! This has been very much the case with locative media projects. Trace Encounters required conference visitors to attach a small 'chip on a pin' to their clothes. This enabled the position of the participant to be tracked at any time during the next three days. The live information was interpreted to provide an on-screen representation of the chip positions within a plan of the conference buildings and this was always on display at one of the central meeting spaces. As discussions occurred and delegates gathered around particular individuals, the screen showed the changing ebb and flow of a complex pattern of social relationships centred now in one place and then another.

→
**Urban Tapestries
Proboscis, 2006
Image supplied courtesy of
Proboscis**

Urban Tapestries used location coordinates within a larger urban environment. This was a large-scale project involving the collaboration of a number of people with different sorts of expertise. For the prototype, the idea was to create a means whereby participants could move around the city and access text information using a Nokia handset equipped with Symbian client software. This read GIS (Geographical Information System) data as they moved to particular locations. They could also write their own messages and leave them as additional markers for other participants as they explored the city streets. Graffiti artists leave their spray-can tags as a way of personalising what they feel is an anonymous city environment. This perhaps helps them to make tangible links with otherwise impersonal and remote surroundings. Urban Tapestries allowed personal history to be interwoven with the fabric and structure of the city. Of course this only became accessible with their use of the GIS device but it pointed towards the new sorts of potential for GPRS enabled mobile phones. Personal histories and memory are inextricably bound up with place and neighbourhood. Urban Tapestries suggested that some of these social narratives could be made more accessible and so add a new dimension to the idea of exploring a city or site of interest.

KB Knowledge Bank

1. Winnebiko (p.119) I and II the recumbent bicycles used by Steve Roberts on his epic journeys across the USA.

2. ASUS WL-HDD (p.119) a wireless hard disk drive manufactured by ASUS.

3. GIS (Geographical Information System) (p.121) positioning system based on location of key landmarks as opposed to satellites.

4. GPRS (General Packet Radio Service) (p.121) a standard for wireless communications in devices such as mobile phones suitable for sending small bursts of data such as email and web browsing.

Mischief and subversion

The 1960s in Western countries saw the growth of great idealism among the generation born after WWII. It was the time of the generation gap, student demonstrations in opposition to the Vietnam War and widespread use of illicit drugs. The Woodstock free music festival in August 1969 marked the culmination of this counter-cultural movement. But it was also the beginning of its demise and its ultimate failure was most clearly demonstrated with the murder of a spectator by Hells' Angels' security at the Rolling Stones' free concert in Altamont, California, in December 1969.

In 'Digital Culture' (2002), Charlie Gere traced links between the hippie movement and the technological revolution represented by Silicon Valley in California. Many of the pioneers of the fledgling computer companies personally made this transition and they brought with them the same values of openness and sharing that lie at the heart of network technology. These were then mostly subsumed within the world of corporate competition but the business practices favoured by Apple, for example, were tinged with an aura that had the same idealistic 1960s origin.

Net activism, hacking, peer-to-peer file-sharing, the open source movement and also viruses are driven by the same commitment to the dismantling of the structures of ownership, corporate business and Internet real estate. During the 1990s, Richard Barbrook identified what he has described as the Internet's hi-tech gift economy. He, and others, expect that this will result in a serious challenge to business models based on the more usual methods of capital transfer in relation to goods.

↑
Google Will Eat Itself
Ubermorgen.com, 2005–06
This is an ingenious and adept example of the way Internet technologies can be made to turn in on themselves. Revenue is generated as the mouse selections of online visitors trigger a further sequence of mouse clicks on hundreds of hidden websites. This revenue is used to purchase Google shares that then become the property of Google to the People Public Company.

KB Knowledge Bank

1. To read Richard Barbrook's (p.122) 'The Hi-Tech Gift Economy', (First Monday, Vol. 3, Iss.12 December 1998) See www.firstmonday.org/issues/issue3_12/barbrook/

2. For more information on Google Will Eat Itself (p.122) and other projects, see www.Ubermorgen.com

3. Jodi (p.123) is a collective of two Internet artists: Joan Heemskerk and Dirk Paesmans. Jodi's works seem inaccessible and impenetrable, appearing to make the user's computer run amok. For more information on Jodi see www.jodi.org/

"Google's position is predominant in the same moment it enters a new business field with a new service. It's the Google effect: creating consensus on a new business, even if it instantly gets the predominant position. The greatest enemy of such a giant is not another giant: it's the parasite."

www.ubermorgen.com/2006/index.html

Art as political action

The artists cited on these pages have seen the power of networks and the way in which online communities can have a deciding influence in the offline world. They seek to galvanise the disparate groupings and provide the means of bringing political pressure to bear to destabilise a status quo they regard as unjust and unchallenged.

Artists want to engage an audience, to connect with the public and influence opinion. Their intention is that their way of seeing things is accepted as true. The discussion arises as to whether the best way to do this is to attempt to undermine authorities and institutions or to focus on developing their abilities in handling their chosen media. For the artists who use a tactical approach in their work, the role of the media they use is subordinated to a politically motivated intention. In fact to a large extent, this intention determines the way in which the media is used.

The Web and politics

The power of the Web in the political arena was at the forefront of Howard Dean's 2004 campaign for the Democratic presidential nomination. He hired Zephyr Teachout to use the Internet (meetup.com) to mobilise the Democrat support. 180,000 Howard Dean supporters were listed on the site at one stage and Teachout noted that:

'the key here is that we are using tools to allow a real shift of power to people that we treat as people more than voters'.
Source news.com. See news.com.com/2008-1028-5142066.html

The campaign was finally unsuccessful in that it failed to convert the online momentum into actual votes in the real world.

←
Max Payne Cheats Only Gallery
Jodi, 2005
Jodi's technical ingenuity allows them to hack proprietary gaming engines and reconfigure graphic content so that avatars within a game are stripped of layers of clothing and body parts. Strange naked mutant creatures now appear in place of the once famous game character (Max Payne), mouths full of teeth open and shut meaninglessly and avatars find they can walk through walls and floors.

Mixed-reality gaming

BLAST THEORY

and the

Mixed Reality Lab

Broadly speaking there are two types, or 'schemes' of mixed-reality gaming. In the first, aspects of real world action, dimensionality and finite spatiality are digitally captured and provide the source of raw data that is used to control corresponding elements within a simulated construct of reality. This is usually displayed on a screen.

In the second, mobile communications networks deliver real-time data to participants giving them the information necessary for navigating the real world and completing tasks that have been assigned to them.

In both these schemes the final goal is either achieved within the real world or within the simulation.

←
Uncle Roy All Around You
Blast Theory, 2003
A collaboration with the Mixed Reality Lab at the University of Nottingham and supported by and Arts & Humanities Research Board Innovation Award, Equator, BT, Microsoft Research and the Arts Council England with Lottery Funds. Copyright Blast Theory.

'Uncle Roy All Around You' has been installed in a number of different cities and uses location-sensitive PDAs and text-based communication with participants. The nerve centre of the piece is in a public building such as a gallery where participants receive instructions and pick up their PDA packs. Here there are also computer consoles where visitors can watch the progress of game players as they move around the city. This is represented within a virtual 3D environment and icons mark the current position of the players.

As might be expected, the purpose of the game is to find Uncle Roy using the sequence of clues that are sent to each PDA from the game's controllers. The game requires considerable knowledge of the host city as the clues offer street names or historical references. It also helps to move quickly once the clue is received.

Game time vs real time

To play any game involves accepting the suspension of normal lifetime and entering a separate game time. It is not usual to find that the time lapse apparent within the closed world of the game narrative should have any relationship with the actual duration of the play. In mixed-reality gaming there is a certain degree of congruence between these two sorts of time and indeed with normal action and game action. It is clearly not an option to press 'Pause' on the game console when walking down a city street while participating in a location-based game! Participation cannot be interrupted. Time has to continue to pass both in the real world and in the mind space that has been created by involvement in the game play. The participant is aware of both.

Developments in mixed-reality gaming

At this stage of development, the technologies that make mixed-reality gaming possible have not been accessible in any widespread way for very long. Artists and creative groups are feeling their way, solving the technical problems as they work and probably needing more time to develop the game concepts that fully exploit the potential of a location and networked environments.

Examples of location games include Pac Manhattan, developed by students at ITP New York and 'Ere Be Dragons', which is a collaboration between Active Ingredient and the Lansdowne Centre For Electronic Arts at Middlesex University. 'Ere Be Dragons' uses a device that reads the player's heart rate. While they explore the locality of the game, points are scored as the player is able to keep their heart rate within given limits. Points can also be scored by 'taking' territory from other players.

With mixed-reality gaming, the meaning and significance of an action is multi-layered. The action has purpose within the physical world but is also transferred by technology so that it has causation within the world of the constructed game. Console games do not implicate human action in the same way. The player's bodily action in a console game has no inherent consequence except as a means of controlling a device such as a joystick that is a purpose-built part of the game interface.

KB Knowledge Bank

1. For more information on Blast Theory (p.124) see www.blasttheory.co.uk

2. For more information on Active Ingredient see www.i-am-ai.net/home.html

> **There has emerged...a whole new medium whose foundation is not on looking and reading but in the instigation of material change through action.**
>
> Alexander Galloway

Online gaming

Gamers are passionate about their play experience and everything associated with it. Anything that detracts from the smooth intuitive player action is seen as an unnecessary complication. For many gamers the addition of online connectivity in <u>MMO</u> (Massively Multiplayer Online) games such as Halo3 or Quake detracts from the immediacy of action in a <u>CTF</u> (Capture the Flag) mission or a first-person shooter, such as, Half-Life or Duke Nukem.

These core gamers, however, may not necessarily be the intended market for the new types of game that will be deliverable with faster broadband networks. For example, the online gaming market is predicted to grow in the Asia Pacific region to reach a value of US $6.8 billion by 2010 (source: In-Stat http://www.instat.com). Countries here are investing heavily in the infrastructure to ensure sufficient support for the increased data rates required by complex gaming environments.

→
Sony Playstation 3, Microsoft Xbox 360 and Nintendo Wii
Games are designed to be played either on a general-purpose PC that is used for other tasks or on one of the three leading games platforms, the Microsoft <u>Xbox</u> 360, <u>Nintendo Wii</u> and the <u>Sony Playstation 3</u>. These last three enhance the normal single- or two-player mode by providing for a connection to the Internet with either a subscription-based membership scheme or free access to the online game playing community.

Money and online games

'When compared with data from the World Bank, a US economist, Edward Castronova of California State University in Fullerton, says Norrath's [the virtual world of the game EverQuest, which a MMO Fantasy Role-Playing Game] per capita income is roughly between Russia and Bulgaria. Or put another way, Norrath is the 77th richest country in the world.'
Source: Sean Dodson, The Guardian, 21 March, 2002.

The predicted growth in the games market is thought to major on the MMO games, but this will also be supplemented by broadband games on demand services. These will make games downloadable to subscribers paying a monthly fee. In 2002, Castronova said the average Everquest player generates $2,266 a year.

Online gaming as a part of Internet connectivity

The essence of online gaming is communal action and team-based strategy development on joint missions. Each new participant provides information that will rank them so that they can be matched with opponents of a similar rating. No one likes to be beaten and failure to submit this information can result in an unequal contest between a novice and a veteran master who has completed all levels of the game many times over. The novice is crushed and does not usually wish to repeat this rather unpleasant initiation into the online world of online gaming.

Key industry players see the action of online play as just a small part of what the experience will involve in the future.

Microsoft launched its Xbox live service in 2005, a year after the release of the game platform, and has been trying to position the console so that it can offer other functionality such as web browsing and become a general-purpose computer platform in the home. MS lost out to rivals Sony and Nintendo in the console wars and sees online gaming as a possible source of revenue to set against the setbacks of the initial launch period. Over 1.5 million gamers connected their machines to the Xbox live launch event in May 2006. The linkup allowed them to download demos of popular games such as Halo3, Gears of War and Call of Duty.

Nintendo's DS, a WiFi-enabled handheld gaming console, has been a successful multiplayer platform. Nintendo have not followed the Microsoft model of subscription-based online connectivity but provides this aspect bundled free with the Wii (the replacement for the GameCube).

KB Knowledge Bank

1. MMO (p.126) Massively Multiplayer Online games such as Halo 3 or Quake

2. CTF (p.123) Capture The Flag games such as Half-Life

3. For more information on the Microsoft Xbox (p.126) see www.microsoft.com/xbox/

4. For more information on the Nintendo Wii (p.126) see www.wii.nintendo.com/

5. For more information on Sony's Playstation 3 (p.126) see www.uk.playstation.com/ps3/

6. For more information on the Nintendo DS (p.127) see www.nintendo.com/systemsds

‟It's not just what you do inside the console, it's how you extend that out into your regular world and the friends and connections you make as well.... Eventually you'll be able to blog there, manage your own photo gallery, and custom manage content.‟

Ryan Schneider, Communication Director, Resistance: Fall of Man (Playstation)

A sense of place

Digital technologies have made possible a detailed knowledge of an individual's location and their proximity to specific geographical landmarks. GIS and GPS devices can use this location information to trigger data events on mobile devices such as <u>PDA</u>s or notebook computers. There are of course related privacy issues and worries concerning the prevalence of surveillance systems and the way in which these could be used to curtail personal freedoms.

There is a need for vigilance if the creative potential of these systems is not to be jeopardised by fears that the security of the data may be compromised in any way.

Personal connections with places

Both Gaston Bachelard in 'The Poetics of Space' (1964) and Georges Perec in 'Species of Spaces and Other Pieces' (1974) develop slightly different notions of space. Both of them have had considerable influence on visual artists using location in their work. While both concentrate on the imaginative apprehension of space, Bachelard explores the way in which personal narratives seem to become snagged in the actual fabric of a domestic living space. Perec expands on this by creating a taxonomy of spatial zones. He gradually works out from the immediate space of a single room, on to the apartment, the street and then all the way to his own national frontiers. Both writers emphasise the importance of place in the world of the imagination, particularly in childhood.

↑
Greenwich Emotion Map
Christian Nold, 2006
The <u>Greenwich Emotion Map</u> recorded the heart rate of participants as they investigated different parts of the Greenwich Peninsula in London. The data was collected and used to visualise the peaks and troughs in these readings as part of an emotional survey map. Driving this work is an understanding that connections with the land are a fundamental aspect of human experience. Digital technologies have provided the means of exposing this layer of hidden reality. It is uncanny to find that those feelings are shared with complete strangers, and surprising to discover the overlap between the world of the emotions and map references.

Into the unknown

Holiday brochures present an idyll of calm and beauty, empty beaches and clear azure skies, the very antithesis of the multi-tasking frenetic activity that characterises normal working life. The brochures proffer an escape route and present travel and exploration as a way out of current concerns and problems. Elsewhere is better, they seem to say. Anywhere is better than where you are right now. And it is often difficult to disagree.

The evocation of place is an important facet of the visual arts. The visual image provides an opportunity for travellers to recall their own itineraries while also serving to entice others to make their own journeys to the same destination.

Locative media afford a method of melding the Cartesian world of dimensionality with the imaginative and subjective responsiveness of artists. With reactive events linked to longitude and latitude values, the artist is able to allow others to enter into their private world of suggestion and reminiscence. All kinds of media can be controlled by these values to provide sounds that coincide with arrival at particular places or video documentary that links lived experience with the history of the locality or the personal memories of the artist. Other approaches have worked the other way and offer systems that monitor the emotional state of visitors as they explore a particular locality.

"Digital technology's ubiquity and its increasing invisibility have the effect of making it appear almost natural."

Charlie Gere, 'Digital Culture', Reaktion Books, 2002

Travelling pixels

The pixel is coloured by the numerical values of red to green and blue. These values can be controlled by a program. This quantisation and its direct relationship with appearance does not serve to lessen the emotional impact of an image. It can still carry a potent visual charge that can cause its constant recreation in the memory.

Place and ownership

It is impossible to avoid dealing with proprietorship when considering geography and location. The Australian Aborigines' approach to ownership was in stark contrast to the early colonists; they made no boundaries and had no frontiers. Perhaps as the boomerang scythed its way through the air they felt its spinning path was evidence enough of their ancient claim to their country, there was no need for any other.

New technology is making possible an ownership of a different order to that based on title deeds and inheritance. Geographic positioning is certainly one part of this, with its ability to trigger experiential interventions based on place, but human gestural movement in relation to the land remains to be explored further. By interpreting gesture in response to location, technology opens up a new type of colloquy with our surroundings.

↑
Glenlandia
Susan Collins, 2005–2006
Susan Collins's Fenlandia and Glenlandia reconstitute images from a succession of single pixels recorded every second by a camera over 24 hours. The pixels are then sent via a network to a completely different location with each scan line building the image from top-down. Collins's work reverses the normal situation by using networks for deceleration, a slowing down of sight.

→
Civil engineering surveyor
The ability to measure geographical space with accuracy might be combined with other responses that are bound up with an awareness of more personal narratives and memories.

KB Knowledge Bank

1. PDA (p.128) Personal Digital Assistant.

2. For more information on Christian Nold and the Greenwich Emotion Map (p.128) see www.emotionmap.net

3. For more information on Susan Collins and Glenlandia (p.130) see www.susancollins.net /glenlandia

"Place is that great object that is the end of the half the labours of human life; and is the cause of all the tumult and bustle, all the rapine and injustice which avarice and ambition have introduced into the world."

Adam Smith, 'Theory of Moral Sentiments'

Telematics
and vicarious experience

Telematics is probably the most literal example of Marshall McLuhan's definition of technology as an extension of man. The finite reach that provides the power of intervention in the immediate surroundings is extended by technology to expand in infinite directions and circumstances. As a result of technology, not being present in a body is no longer a restriction to my ability to have critical physical impact in a location from which I am separated by distance. This is an extension of experience no longer confined to one place and time. Technology makes multiple localities a reality. In the terminology of William Gibson's book 'Neuromancer', it is possible to flit from place to place to 'jack in' and 'jack out'.

Empathy

The most common experience of telematics or vicarious experience is in the world of online role-playing games. The character in the game scenario has a set of character traits that are not those of the game player. The action in the game is only engaging if each player evaluates changing events from the point of view of their character rather than themselves. It is important for the success of the game that this happens:

'The ability to identify and distinguish the virtual mediated world or gaming world from the real is a necessity that provides a safe distance enabling users and players to gain experience and pleasure.' Source: Tim Marsh, 'Vicarious Experience' in 'Gaming as Culture'.

So the player empathises with the character and proceeds to make the character act accordingly.

The immediate environment of experience is mediated by the body's apprehension of a whole set of laws relating to gravity and the restrictions of the surroundings. There is also an awareness of the proximity of others and the kind of cultural etiquette needed to make appropriate communications with them. Alongside this, auditory senses assist with balance while visual clues help to determine distances and the number of steps required to move from one side of the room to another. It would be very difficult to simulate this complex array of local conditions within a simulated environment.

Paul Virilio has shown in 'Open Sky' (1997), and other books, that the primacy of physical presence is being undermined with each telematic extension of power. The finite self's effective action in the immediate environment is diminished and there is a resulting crisis of kinetic potentiality. As distance is collapsed by technology, then the near seems to lose out in a battle with the far.

KB Knowledge Bank

1. Telematics (p.132), the collision of circumstances separated by geographical space. It refers to any sort of technology that makes possible real-time transfer of different kinds of data so that motor action of any sort is causative in another location.

2. See Marshall McLuhan's (p.132), 'Understanding Media: The Extensions of Man' (Routledge, 1964).

3. See William Gibson's (p.132), 'Neuromancer' (Voyager Paperback, 1995).

4. See Tim Marsh's (p.132), Vicarious Experience' in 'Gaming as Culture: Essays on Reality, Identity and Experience in Fantasy Games', Williams, JP, Hendricks, SQ and Winkler, WK (Eds) (McFarland & Co, 2006).

5. Vicarious (p.132), being at one remove. Experiencing what occurs through the agencies of another.

6. For more information on Paul Sermon (p.133) take a look at www.paulsermon.org

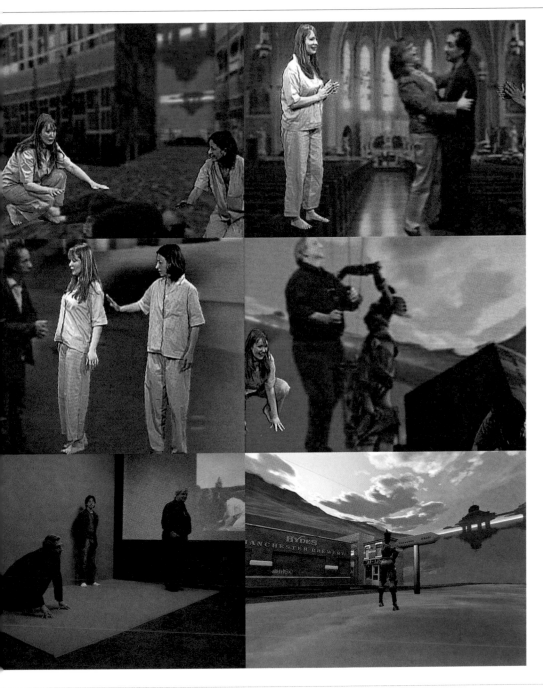

Uheimlich
Paul Sermon 2005
Paul Sermon's work
asks important questions
about just how much of
this complexity is required
in order to communicate
effectively at one remove.
In 2005, live video footage
of participants in Rhode
Island and Salford
Universities was
synthetically merged
against the same
background. The
participants were able
to see the composite
camera feed from both
locations and respond to
the action in real-time.
In effect each of the
players could only fulfil
their role effectively by
empathising with the
image of themselves as
they appeared in the
composite. This was a
strange technological
tautology, a sort of
simulation of a simulation;
a mediation of a
mediation.

Collaborative art using networks

With increasing frequency, artists have collaborated using networks in a variety of ways in order to achieve their aims. The use of networks in this way broadly follows one of four paths:

1. The use of networks where they are designed to collect information that becomes the central focus of the work; essentially they become an invisible technological aspect.

2. The use of networks as a form of interventionism.

3. The network itself takes on a central role and in some ways almost is the work.

4. The use of networks as a component within a work to combine a live element with other media.

The categories here demonstrate that artists use networks in any way that assists them in realising their idea. There are no particular rules about how this has to be done. The tradition of networked collaborative art is not new and Mail Art used the Postal Service to bring together contributions from artists in many locations. Fluxus also used some networked collaborative methods. There is also the example of László Moholy-Nagy's Telephone Paintings of 1922 where he gave his instructions over the telephone using graph paper and a standard industrial colour chart.

Susan Collins's In Conversation was both an online and a gallery-sited work. Participants online could forward a text phrase, which was then spoken by a disembodied mouth projected onto the pavement and immediately outside the gallery. Passers-by could also respond to the phrases spoken. Essentially the artist had created a means by which strangers could enter into a collaboration with each other.

←
Images from PORTA2030
Alexei Blinov, Shu Lea Cheang and Ilze Black, 2006
Courtesy of Ilze Black
This work by Shu Lea Cheang with collaborators Ilze Black and Alexei Blinov uses the Hivenetworks concept developed by Raylab to engineer new sorts of networked experience. In an imaginary future where all the central networks may suffer interruption or constant surveillance, PORTA2030 presents the notion of a do-it-yourself home-grown independent network providing the means whereby connectivity is available in a portable format.

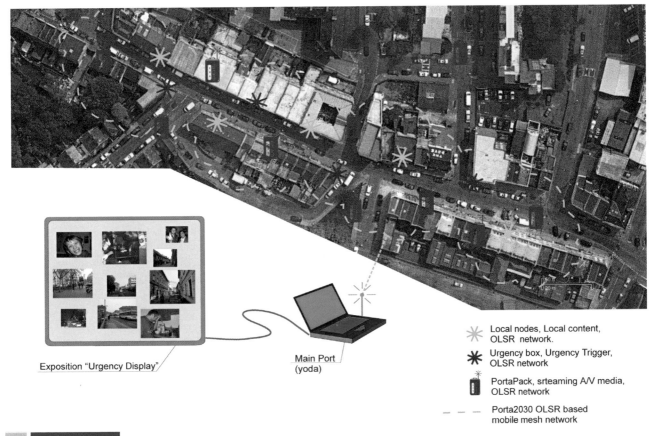

Exposition "Urgency Display"

Main Port
(yoda)

✳ Local nodes, Local content,
 OLSR network.

✳ Urgency box, Urgency Trigger,
 OLSR network

▯ PortaPack, srteaming A/V media,
 OLSR network

– – – Porta2030 OLSR based
 mobile mesh network

↑
Hivenetworks Network
Diagram for PORTA2030
Image supplied courtesy of
Raylab
Hivenetworks convert
wireless hard disk drives
so that they can become
intelligent nodes within
a small local wireless
network. The live
performance was installed
at Broadway market in
east London with 'porters'
roaming in the local
area and video streamed
back for display on a
combined screen.

KB Knowledge Bank

1. For more information on Mail Art
 (p.134) see www.actlab.utexas.
 edu/emma

2. For more details on Fluxus
 (p.134) see www.fluxus.org
 /12345678910.html

3. For information on In
 Conversation (p.134) and Susan
 Collins see www.ucl.ac.uk/slade
 /inconversation/brighton.html

4. For information on PORTA2030
 (p.134) see www.porta2030.net

**❝In the age of the information highway
the last luxury is, in a sense, a context.❞**

Wired from Artforum

6 Digital hybrids

Our world is wired and we can't avoid being connected. Digital artists
have taken up the challenge of reinventing art in a wired world. They
have looked at methods used by business and appropriated these to
ask questions and to create contemplative, deeply significant work
that crosses boundaries and opens up discussion.

Taking creative risks with technology

Beginning to work with digital technology as an artist raises particular challenges that need to be considered. Many artists begin to use digital technologies because there are not so many conventions constraining accepted sorts of practice. Although it is 50 years since artists first used computers for making art, it is still somewhat unformed as a practice. It is still fluid and supple and artists feel that they can test out what can be done. It is also crucial that the inherent quality of the media is understood.

Developing digital artwork

It could be suggested that these new schemes come about as artists work to create a balance between four important facets of their practice. These are:

1. The conception of the idea.
2. The technological innovation needed.
3. The craft or production skills.
4. The chance or wildcard component.

There will of course be many others, but to describe these might help to understand why some works are more successful than others. At different stages these four aspects will occupy more or less attention than the others. It is obvious that if a program is needed, at that point most of the artist's attention will be taken up with that. Later on, it may be that electronics skills are required. The artist has to manage their own creative timetable so that each aspect contributes to a successful final work.

The chance or wildcard element is sometimes more important in one work than in another. The Eureka moment, when everything falls into place, often follows directly after a period of frustration and this could also involve some sort of unplanned event. It is these kinds of occurrences that can suddenly serve to make sense of all those times where a solution was just not forthcoming at all. They provide a surprising perspective and bring sudden illumination where everything seemed completely unclear.

Concept or central idea Technological innovation Craft skill Chance or wildcard element

← Developing a digital artwork
This diagram shows the way aspects of the work can progress at different rates. At one stage the project will seem to be mostly centred on a particular technology and this usually happens because the technology provokes questions about how it can be used. Later on the project may involve the development of certain craft skills. The aim is that these complementary strands do not conflict or obstruct each other.

⁴⁴It is no great achievement to transfer traditional artistic patterns and behavioural schemes into art. The challenge is to create new ones.⁴⁴

Timothy Druckrey, 1999

Random working processes

Random procedures of different sorts may be useful here. If a sufficient number of variables are used in a program, for example, the artist can bring things to the point where they literally have no idea what may happen on pressing the Enter key. Yet they are still in a position where they make judgements about the results. They use their knowledge of the world, their tactile sense, their awareness of gravity and physics and their receptiveness to the properties of colour. The computer itself does not have these sensibilities in the same way. However, it reorders the material it is given and generates colours and forms itself and as it does so, the artist can intervene at any time and exert their influence on what is happening.

Combining media

Creative risks can also be taken by combining media in new ways. Where there is no precedent of practice, it is harder to find acceptance for it. However, innovation of this sort can open up the discussion and provoke the strong reactions that will ensure that the artist's work remains current in debate while also opening the way for others to use similar approaches.

In 'The Language of New Media' (2001), Lev Manovich spent time developing a very clear description of the differences between montage and compositing in video. In his analysis, compositing tries to disguise the fact that two sequences have been combined together. In montage, the aim is to accentuate differences and create an aesthetic based on juxtaposition. When an artist combines media, they need to be aware that there may be more to be gained from accentuating the two separate sources rather than trying to make them into a seamless whole.

Later in this chapter (see Working across media and platforms, page 150), there are examples of this kind of practice, particularly in relation to projected images where the projection surface is not a passive component but actively combines with light to play its part in the realisation of the work.

←
Software As Furniture
(top)
Daniel Brown, 1997
and
The Deluge (bottom)
(after Leonardo, Giclée Print, 50cm/20in square)
Paul Brown, 1995
There are many artists working with algorithmic procedures where certain values are decided in real time by the program. Paul Brown has used such methods and his son Daniel Brown has a well-deserved reputation as a programmer with an acute sensibility for the organic structures behind nature and reality. Both these artists are focused on process rather than final product but this is not what is most apparent when looking at their work. The emphasis may be on process but the works engage on many levels as complete statements. Although they may have been 'stepping stones in the mist' to quote Paul Brown, they still enable us to find our balance and look both backwards and forwards.

KB Knowledge Bank

1. For information on Paul Brown (p.139) see www.paul-brown.com

2. For information on Daniel Brown (p.139) visit www.danielbrowns.com/saf.html

Virtual environments

The dictionary definition of the word virtual is 'having the essence or effect but not the appearance or form of'. In other words a virtual world appears to offer a reality that is not actually there. The world that does appear exploits the fact that human vision is conditioned to decode visual stimuli in order to judge distances and potential obstacles and will perceive spaces where one object is seen to move behind another. Some virtual world systems use headsets equipped with small screens that completely replace normal vision. Other systems project imagery on the floor and walls of an enclosed space.

A seamless and uninterrupted expansive landscape is formed by ensuring that the projections are stitched together in a way that makes full use of 180 degrees of vision. The tendency of human vision to be convinced by such images was most powerfully demonstrated in the early period of cinema where the audience all left their seats in fear when confronted with the Lumière brothers' 'Arrival of a Train'. This showed a train approaching a Paris station at full speed and it appeared to the audience that they were in actual danger.

Jaron Lanier is credited with inventing the term virtual reality in the early 1980s. After this there were virtual art projects such as Jeffrey Shaw's Legible City. The interface was a bicycle and the pedals controlled movement through a 3D city constructed from words.

← Head-mounted computer vision system
Such systems require a high level of commitment from the user and replace normal vision completely.

← Trompe l'oeil door, Jewish Quarter, Pézenas, France
This is an excellent example of 3D trompe l'oeil. The rules of perspective used for representing the 3D world are applied to the 3D world itself, causing strange visual feedback.

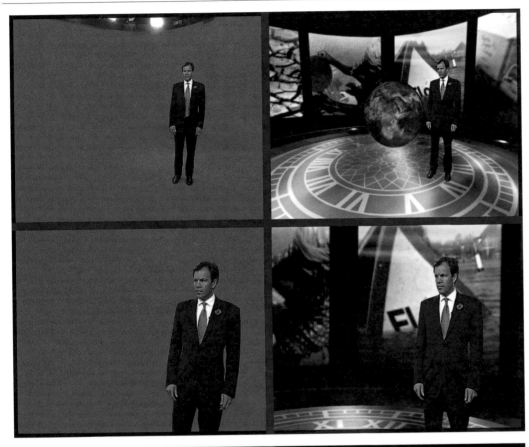

ITV's theatre for news VR system
Photo: Suzette Colson & ITV

ITV news has won awards for its development of a news 'theatre', constructed with a 22 x 3m (72 x 10ft) translucent video wall and VR system. The system is able to match up the position of the presenter within the VR theatre and display graphic and 3D content associated with the news item being covered. The presenter stands in front of the chroma-key green background and the video source is composited so that it appears that they are standing in front of the curved video wall. The broadcast image is actually completely virtual.

Examining virtual reality systems

A virtual reality system needs a real-time 3D processor that is able to render complex polygonal structures, lighting conditions and textural surfaces all at a speed that is acceptable to normal human vision. The systems also read variables such as head movement and position and these determine location in 3D space and the angle of view.

To be completely immersive, a virtual reality experience needs to consist of more than a rendered 3D space. Rendered spaces can seem sterile and without sufficient variation. In order to engage the subject more fully, other factors such as atmosphere, sound, speed of movement, gravity and weight also need to be addressed. These all impinge on everyday experience and if they are absent, although the environment may be impressive, it may still seem remote.

Within these environments a decision has to be taken as to whether it is feasible to attempt to mimic real experience or to construct an alternative kind of space entirely. For digital artists, flight simulators may be extraordinarily convincing training systems but such systems have no capacity to self-reflect. The technology is used to convey an experience rather than offering an opportunity for the viewer to enter a dialogue involving both the medium and their own responses to it.

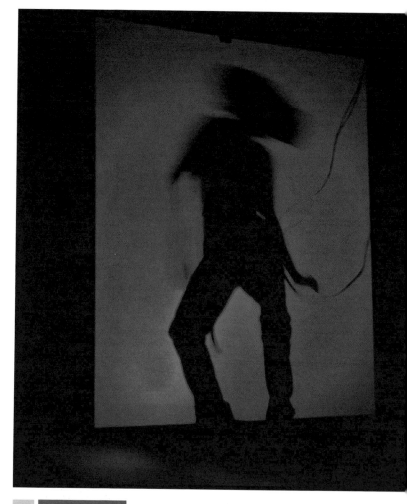

KB Knowledge Bank

1. For more information on Jaron Lanier (p.140) visit www.well.com/~jaron/

2. For information on Jeffrey Shaw (p.140) see www.jeffrey-shaw.net/

3. For information on Char Davies (p.143) and Osmose, visit www.immersence.com/osmose/index.php

←
Osmose
Char Davies, 1998
This work is an example of the potential of true symbiosis between the artist and computer. The subject puts on a jacket that monitors changes in breathing and this is the data that is used to control position within the 3D world. Osmose's algorithms use this data as variables within its sensitive handling of acceleration and deceleration of the position in space, resulting in spongy, organic movement very similar to swimming. Sounds also contribute another layer to the complex and amorphous virtual world. It is not surprising that some people who have experienced it have found it very disturbing and at the end of their session found returning to reality a very powerful emotional wrench.

"What we have in virtual reality is the ability to directly make up shared reality instead of talking about it. Virtual reality now provides us with an alternative to go back and explore what might have been."

Jaron Lanier, 'Riding the Giant Worm to Saturn' in 'Post Symbolic Communication in Virtual Reality'1990

Changing interfaces

An interface is best understood as an elision. This elision is between two different worlds and the interface is the boundary between them. To continue the analogy, the interface is like a customs post that supervises the kind of goods that can be transported from one side of a border to the other. Some things on one side have a direct equivalent on the other side but others are not understood at all and are not permitted to cross the barrier.

In order to ensure that trouble-free exchange occurs, it is necessary to do a certain amount of repackaging so that material is accepted at the border crossing. When using an interface, normal everyday action is suspended for this period of time and although it still continues, it is its interpretation within the new context beyond the interface that takes precedence over events in the real world. On first encountering an interface, there is usually a period of uncertainty, investigation and exploratory action. As time passes, this uncertainty is replaced by a growing confidence as responses are found to be consistent and the user is able to refer to past experience and their short-term memory. It is unsettling to find inconsistency at this point and if this persists the result could be an irreparable break between the user and the system.

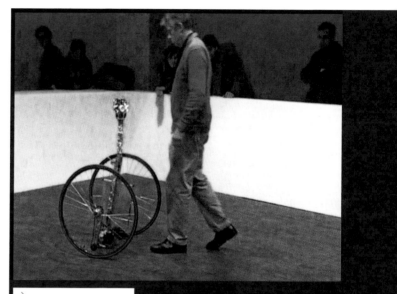

→
Petit Mal
Simon Penny, 1989
Simon Penny says that 'the goal of Petit Mal was to produce a robotic artwork that was truly autonomous;...that sensed and explored architectural space and that pursued and reacted to people'.

Petit Mal's behaviour could never be relied upon. There would always be inconsistencies that suddenly challenged the visitor's confidence in being able to say that they had understood the rules controlling its actions.

> "An aesthetically potent environment encourages the...viewer to explore it, to learn about it...it makes him participate."

Gordon Pask

The fundamentals of digital art Digital hybrids

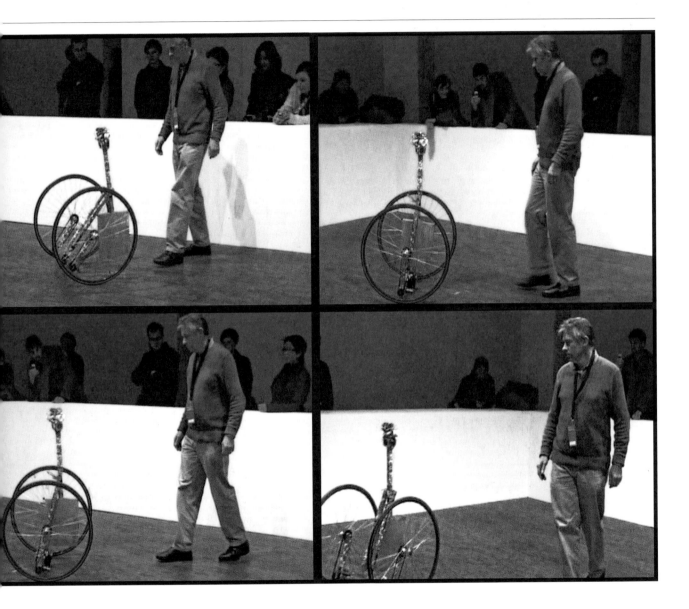

↑
Sensors

In order to widen the kind of information an interface can use it is necessary to monitor changes using sensors designed to measure movement (1), angle of bent (2), tilt (3), light (photocell) (4), angle of revolution (e.g. volume control) (5), temperature (6) and pressure (7).

These are best used with a micro controller such as the Arduino but can also be bought as a kit with the I-cubex system. This converts sensor readings to MIDI values (between 0 and 127) and these can be read by Processing, Max/Msp or Flash so that they can respond accordingly.

Designing interfaces

The role of the user is clearly crucial and by deciding what sort of contribution they will make (if any) different components can be ruled in or ruled out while others are given more or less prominence. It can be a frustrating experience to use an interface that only has one possible route through its content as this will not encourage the visitor to explore and make further visits, and undervalues their contribution.

It is possible to classify interfaces. At one end of the scale, nothing is expected of the user, they are only the audience. At the other end they are given the responsibility for everything and all events are dependent on what they do. It is also possible to compare interfaces in terms of the types of information they are able to process. Some are minimal in the sense that they expect the user to go into computer mode and use the usual computer peripherals. Lev Manovich looks towards the creation of a new cultural metalanguage that arises from a synthesis of media available. He makes the point that it is actually very difficult to accept the computer as the source of culturally significant content when it was originally designed to be a calculator, a control mechanism or a communication device. Here perhaps is the most important reason for inventing interfaces that cannot immediately be identified as computers.

The structure of the interface is critical. Repeated material, a lack of flexibility, the absence of feedback, and an attitude that is oblivious to the richness of human sensibility are all going to have a negative effect on the way the interface operates and is perceived. Interfaces need to make use of methods that can record the amount of time a user has been engaged and they need to keep providing the kind of information appropriate for individual needs.

KB Knowledge Bank

1. Simon Penny (p.144) is Professor of Arts at the California Institute for Telecommunications and Information Technology.

2. Musical Instrument Digital Interface (MIDI) (p.146) is a standard protocol for the interchange of musical information between musical instruments, synthesisers and computers.

3. Lev Manovich (p.146) is Professor of Visual Arts at the University of California, San Diego. For more information on Professor Manovich see www.manovich.net /LNM/index.html

4. Metalanguage (p.146) can refer to any terminology or language used to discuss language itself.

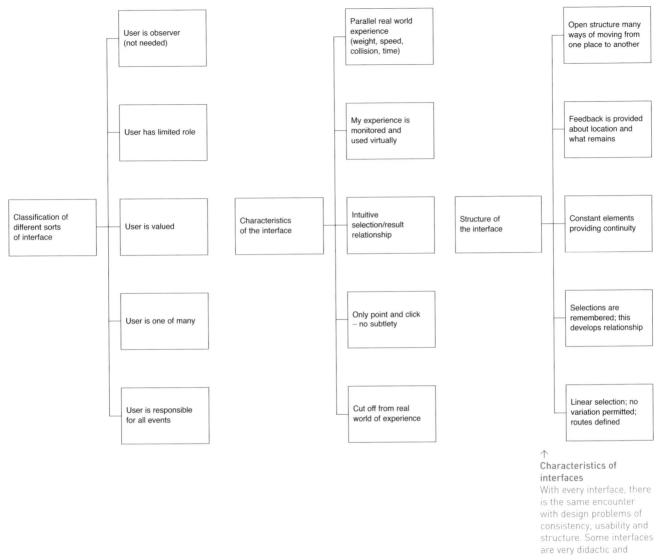

Classification of different sorts of interface		Characteristics of the interface		Structure of the interface	
	User is observer (not needed)		Parallel real world experience (weight, speed, collision, time)		Open structure many ways of moving from one place to another
	User has limited role		My experience is monitored and used virtually		Feedback is provided about location and what remains
	User is valued		Intuitive selection/result relationship		Constant elements providing continuity
	User is one of many		Only point and click – no subtlety		Selections are remembered; this develops relationship
	User is responsible for all events		Cut off from real world of experience		Linear selection; no variation permitted; routes defined

↑
Characteristics of interfaces
With every interface, there is the same encounter with design problems of consistency, usability and structure. Some interfaces are very didactic and controlling while others are built to be flexible and responsive to a range of variables.

The diagram tries to compare some of these approaches. It is important to ask critical questions about the character of an interface at an early stage. It is always more difficult to make modifications later on.

"All culture, past and present, is beginning to be filtered through a computer, with its particular human–computer interface."

Lev Manovich

Negotiating with specialists

↑
Team meeting
Soda have been working
for over ten years as a
creative solutions
company. Their portfolio
includes the soda
constructor and a number
of public projects such
as the energy ring at
the Science Museum
in London.

There may be a tendency for artists to develop working practices that are not sufficiently outward looking and a resulting danger may be that they become insular. As their practice starts to involve increasingly complex technologies, it is unlikely that an individual artist is going to have the required level of knowledge to deal with every aspect of a project. In art schools, students are asked to look within themselves for their ideas, to develop independence in creative processes. This is because they will need enormous self-reliance to be able to continue as artists once they can no longer rely on the supporting environment of the college.

The problem is that this independent spirit may prevent them making connections with an assortment of professionals who might actually be beneficial in developing new kinds of approach in their work.

Learning to collaborate

How can digital artists ensure that they are in a position to capitalise on opportunities that might arise from collaborating with other specialists? Clare Cumberlidge (co-director of the General Public Agency), in her essay on 'Transdisciplinary Practice' for a-n magazine, points to four qualities:

1. An ability to listen.
2. An interest in and respect for others.
3. An intense curiosity.
4. An inquiring mind.

Although her particular interest centres on public art projects, she touches on many of the same issues that affect other creative initiatives requiring negotiation with a team. These include the need to clearly define roles, the need for an agreement on the brief, and the need to attribute value to each member.

Empowering software

Technology has allowed different creative domains to meld and has blurred the edges between disciplines. Technological advances are oblivious to restrictive work practices and demarcations that prevent the spread of knowledge. As a result, new channels of transdisciplinary exchange have opened up. Artists can discuss ideas with musicians and designers work regularly with engineers.

New software may seem to empower. However, just because a computer program can mix sound, it does not necessarily follow that it should be used by someone without the relevant experience and training. The specialist will still have a matchless knowledge of their particular sphere of practice and developing skills to negotiate with them will usually secure the best results.

> **❝I believe that creativity is essentially transdisciplinary – the unexpected connections, leaps, oppositions of creative responses do not respect the barriers and borderlines of discipline or profession.❞**
>
> Clare Cumberlidge

Analysing group dynamics

Social scientists study human behaviour in the context of the workplace, the home and in leisure situations. They also examine skill development and learning. Much of their work is useful in understanding group dynamics and the factors that come into play in creative negotiations as well. There are particular roles within a group structure. These may not necessarily relate to the kind of expertise that an individual is contributing.

In 'Principles of Organisational Behaviour' (2004), Rhodes and Fincham provide a useful analysis of these roles that is worth bearing in mind if artists are to ensure that all contributions from group members are afforded equal value. They argue that the following roles can be usually be found in all groups:

The Coordinator: someone with the strongest role in deciding on the group's goals and agenda.

The Plant: the ideas person, the person who originates the thinking on which the group depends for its direction.

The Implementer: someone who is happier in a more task-oriented role; focused and particular in scope.

One of the benefits of working in a group with specialists is that it provides an opportunity to bounce ideas off colleagues. The downside to this is that exchanges of this sort can be time-consuming and result in a lack of decision-making.

Rhodes and Fincham also explore the different stages in the group's lifecycle and draw the conclusion that, from conception through to implementation, group collaborations will journey through four periods. These are:

Forming: the period where the group is deciding what it is trying to achieve and its terms of reference.

Storming: this period is characterised by sharp disagreements on strategy. It is also a time for confirming individual roles.

Norming: following on from discussions, the result is co-operation and agreement.

Performing: allocation of tasks to group members and work processes are established, tested and implemented.

Clare Cumberlidge makes the point that there are often unexpected connections across disciplinary boundaries that can result in radical new ways of thinking. Negotiation of any sort is never easy. There are pitfalls and problems relating to intellectual property. The lone creator probably has a more stress-free life but they may also have missed opportunities to move their practice into completely different creative territory.

↑
Constructive criticism
Students on the BA Digital Arts course at Thames Valley University discuss progress in their project work with Axel Stockburger (d-FUSE) and Daryl Clifton (OnedotZero).

KB Knowledge Bank

1. For more information about Soda (p.148), see www.soda.co.uk and to find out more about their soda constructor visit www.sodaplay.com

2. For more information on a-n magazine (p.148), see www.a-n.co.uk/cgi-bin/db2www.exe/home.d2w/input

3. For information about d-Fuse (p.149), see www.dfuse.com

4. For more information about OnedotZero (p.149), see www.onedotzero.com/home.php

Working across media and platforms

Artists need to break free of norms and often feel the need to strain against the pressure to accept practices that are compatible with an agenda set by the mass media. Global international businesses rely on the establishment of markets that are not limited by national borders and culture. Homogenisation of cultural differences assists such businesses to secure the scale of markets they require for their products.

Digital artists use many of the same sorts of media that are important in pursuit of these commercial aims. But they do not want their creativity restricted by the need to communicate the 'killer strapline'. They want to work across media in the pockets of territory where creative practices do not yet have the seal of approval from business. These are often difficult to identify and do not remain outside commercial interests for long. But practicalities also play a part here. To install any sort of large-scale work using digital media requires considerable financial resources. Artists need to look carefully at independent sources of funding in order to be able to embark on the ambitious schemes they may be planning. To remain outside the world of business is a decision that may limit what is possible; such freedom comes at a cost.

→
Spax-oid Cube
Joel Cahen and Julian Ronnefeldt, 2006
Exhibited at NODE.London, the Spax-oid cube uses projection but in this case the aim is to emphasise the immateriality of image and data. This is achieved by projecting onto stretches of flexible semi-transparent gauze material hung one behind the other. The projected image is gradually weakened as the light progresses from one layer to another. The result is an impression of memories gradually fading, after-images glimpsed at random out of the corner of the eye with one quickly following on after another.

"The core challenge of digital art is to establish the relevance of the physical space in relation to virtual space."

John Maeda

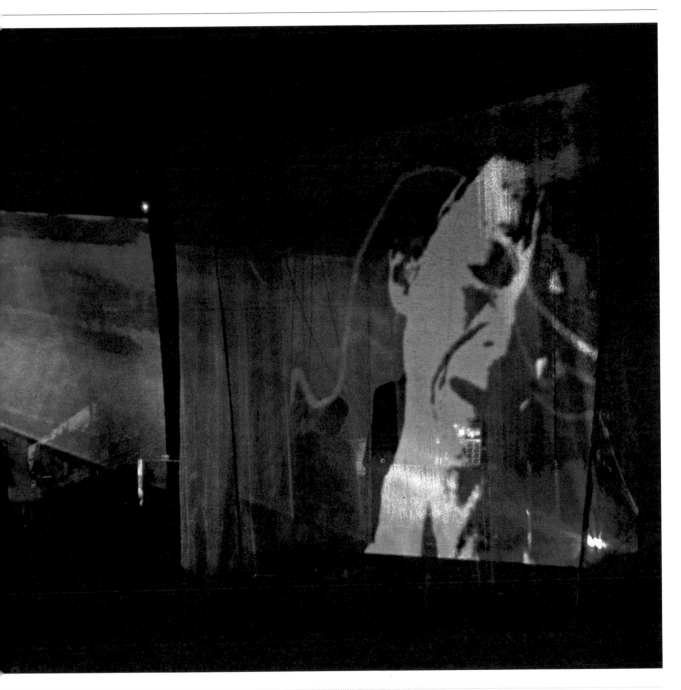

The power of projection

Images on a screen do not have the physical impact of the projection. The projection has a quality that dominates a dark space and the intensity of contrast becomes a compelling centre of interest. Artists sometimes feel that it is enough that the image they prepared on the screen is simply projected onto a wall. An encounter with the work of the French artists Electronic Shadow soon shows how such an approach does not begin to exploit the real potential of projection as a means of transforming a 3D space with light. This is essentially what their work achieves. Careful thought is given to the image of course, but equal attention is paid to the way that the image will carve through the projection space but can be applied to only one 3D surface.

KB Knowledge Bank

1. For more information on the Spax-oid Cube (p.150) see www.newtoy.org

2. For information on Electronic Shadow (p.152) see www.electronicshadow.com

3. For details about the Ames Room (p.152) see www.psychologie.tu-dresden.de /i1/kaw/diverses%20Material/ www.illusionworks.com/html /ames_room.html

4. For information on the ITP Tisch School of Arts (p.153) see www.itp.nyu.edu/itp/flash/Home

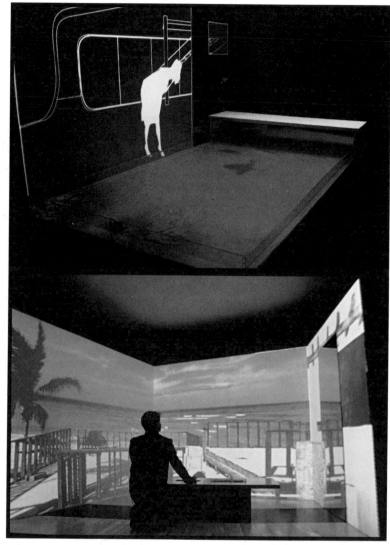

↑
H20
Electronic Shadow, 2004
Projections can transform spaces, animating each surface and causing the eye to read distance where there are only flat, white walls. This work is a dynamic application of the Ames Room effect. But rather than a demonstration of perceptual conundrums, there is commitment and intention here and the purpose is to engage the audience by a complex array of visual sensations.

"In the hands of students who treat the computer as a plastic medium, the creations are as varied as you might expect when metal, plastic and plywood were introduced into the artistic realm."

John Maeda

↓
Animalia Chordata
Gabriel Barcia-Colombo, 2006
Photo: Tom Igoe
Projection can also be used to achieve intimacy. Projectors are reducing in size with changes to the technologies required to output the necessary light levels. This student at the ITP: Tisch School of Arts, New York, projected images of figures inside a row of bottles combining a projected image with another sort of 3D space. Again, thought has been given to the size of the image in relation to the chosen viewing context.

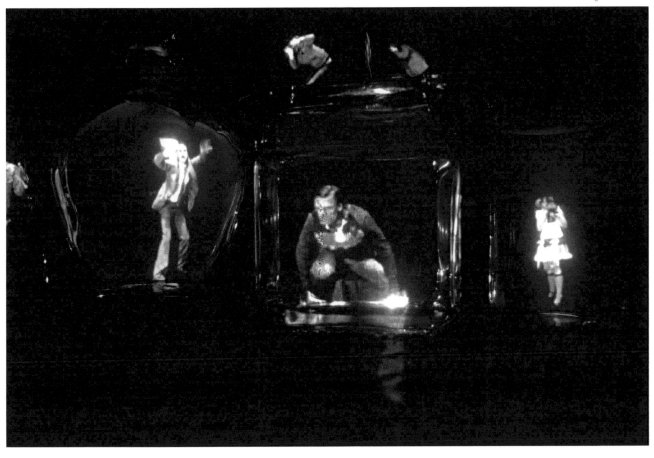

Digital media and other practice

It could be argued that there is a discrete <u>digital aesthetic</u> that bears no relationship to other practice and modes of working. The only problem with this is that it prioritises digital media against sculpture or painting because in these media, discussion centres on the content of the work in question rather than its means of production. In discussing digital media, there is a temptation to spend more time trying to work out how something is done rather than keeping the attention on the direct experience of the work and its coherence judged on its own terms.

It does not help in this regard that there is so much awareness of the steep learning curve associated with certain forms of digital media. The logic almost runs to the point where there is a tacit agreement that if something requires so much effort it must follow that it must somehow be of high quality.

There are also unspoken rules that restrict artists so that if they work with one set of tools others are thought to be 'off-limits'. This book has tried to cover the varieties of practice being pursued under the heading of digital art and it should be clear from this that such rules do not really exist. There is much to be learned as artists move from one sort of media to another. For example, they might bring with them a sensibility gained from coding and this then has a profound effect on the way they draw or use paper.

But the processes involved in digital art are demanding. There is no real way round this. It takes time and commitment to become fluent with these media and this should not be downplayed. This necessarily means focusing on the area for a period of time probably to the exclusion (at least temporarily) of all other means of expression.

Art returns the viewer to reality. It widens their horizons, touches their sensibility and sharpens their awareness of their own physicality. This happens because the artist has managed to unlearn all those habits that prevent real communication with their own intuitive responses at a very instinctive level. Digital media does not prevent this and in fact with developments going on there will be an increasing number of methods of digitally capturing the nuances of those very personal sensations so that they can be used as a starting point within a digitally mediated world.

↑
Location Space Time
Joseph Watling, 2006
Location Space Time was exhibited at the London Metropolitan University Degree Show. This is a visual conundrum combining an 'imaged' reality with the facts so that the piece reveals this constant state of interdependence. Is the world behind the screen more real than the chair that occupies actual physical space?

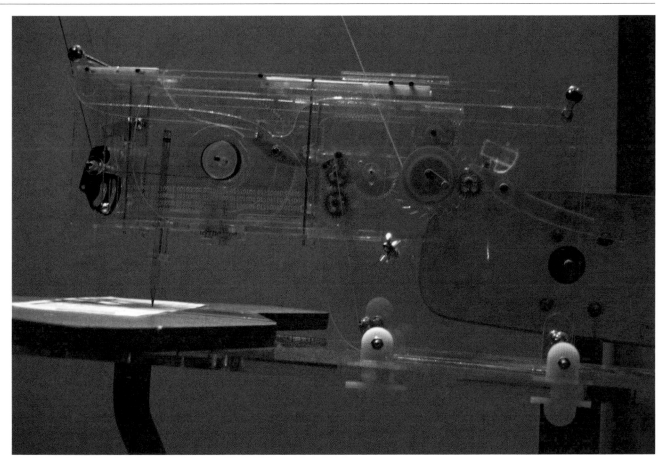

KB Knowledge Bank

1. For more information about
 digital aesthetic (p.154) visit
 www.digitalaesthetic.org.uk

↑
The 'Is Our Machine
Learning?' Machine
Christian Croft (ITP New
York)
Photo: Tom Igoe
This drawing machine is
using a pencil. Does that
mean that is it is not really
an example of digital art?
The tactile sense of
materials in the studio is
still important at ITP in
spite of the time students
devote to the intricacies of
an electronic circuitry.

Postscript

This book has arisen from a genuine desire to reflect on digital art from the point of view of a student or professional practitioner, in the hope that this will provide insights that would then become available to others using similar sorts of media. What follows is a range of additional resources that will help your continued exploration of digital art.

The fundamentals of digital art

Conclusion

It is the effort and ingenuity of digital artists that have been the focus of this book. Their work transforms what is just a potential into a means of expression that provokes a reaction and creates discussion. The result is a dynamic context in which others discover that they can make their own contributions to this practice that is continually in a state of flux.

These artists keep abreast of technological developments, they ask questions, they learn new programs and collaborate with others where they need specialist expertise. They are most likely to be found perpetually online, communicating and sparring with colleagues as they try to come to terms with concepts that are slightly beyond their current creative horizon. That horizon is determined both by their technical knowledge and their own grasp of their capacity as creative artists. It is when they refuse to be restricted in either of these aspects of their practice that we see the surprising and innovative work that this book has tried to draw attention to.

Any book is necessarily only a partial picture, and in no sense is this book designed to be a definitive guide to all digital art, if any such were possible. The book has tried to provide an overview. It is an attempt to draw together the key historical events that have had an influence on the way artists have worked, the thinking that has served to underpin their approaches and the complexity of the technologies that they have used. That complexity means that it has only been possible to introduce some of these areas. Those readers who are interested, will need to supplement the information here by referring to books and websites in the accompanying list in the Further resources section.

The main intention has been to provide a quick scan across a broad area of practice in digital art and lay down some key markers so that the reader can navigate their way within the subject with a growing sense of assurance and knowledge.

→
Treacherous Light
Tim Head, 2002
Digital projection from a
real-time program
(3.75 x 5m/12.3 x 16.4ft)
Photo: Tate Photography,
David Lambert
Programming by Simon
Schofield. Installation
as part of the exhibition
'Days Like These: Tate
Triennial exhibition of
Contemporary British
Art 2003' held at Tate
Britain, London.

Further resources

Books

Ascott, Roy
Paysages Virtuels
Dis Voir 1988

Ascott, Roy
Telematic Embrace
Blackwell 2003

Bachelard, Gaston (with Etienne Gilson and John Stilgoe)
The Poetics of Space
Beacon Press 1994

Barbrook, Richard
The Class of the New Mute
Mute 2006

Baudrillard, Jean
Simulacra and Simulation
University of Michigan Press 1994

Bell, David, and Kennedy, Barbara M (ed,)
The Cybercultures Reader
Routledge 2000

Benjamin, Walter
Illuminations
Pimlico 1999

Biocca, Frank
'The Cyborg's Dilemma: Progressive Embodiment
in Virtual Environments'
Journal of Computer-Mediated Communication Vol. 3, Iss. 2. 1997

Burnham, Jack
Beyond Modern Sculpture: The Effects of Science and Technology on
the Sculpture of This Century
George Braziller 1970

Bush, Vanavar
As We May Think
http://www.ps.uni-sb.de/~duchier/pub/vbush/vbush-all.shtml

Coupland, Douglas
Generation X
Abacus 1991

Coyne, Richard
Technoromanticism: Digital Narrative, Holism
and the Romance of the Real
Leonardo 2001

Dewey, John
Art as Experience
Capricorn Books 1958

Druckrey, Timothy
Electronic Culture: Technology and Visual Representation
Aperture 1996

Druckrey, Timothy (ed)
Ars Electronica: Facing the Future, A Survey of Two Decades
Prix Ars Electronica 2001

Druckrey, Timothy
Iterations
MIT Press 1994

Duguet, Anne Marie (ed.)
Smile Machines
Transmediale 2006

Ellul, Jacques
The Technological Society
Columbia University 1964

Galloway, Alexander
Gaming: Essays on Algorithmic Culture
University of Minnesota Press 2006

Gere, Charlie
Art, Time and Technology
Berg Publishers 2006

Gere, Charlie
Digital Culture
Reaktion Books 2002

Gibson, William
Neuromancer
Voyager Paperback 1995

Gibson, William, Clarke, Julie, Druckrey, Timothy, Goodall, Jane
Stelarc: The Monograph
MIT Press 2005

Goldberg, Ken
The Robot in the Garden: Telerobotics
and Telepistemology in the Age of the Internet
MIT Press 2001

Grau, Oliver
Virtual Art
MIT Press 2003

Gray, Chris Hables
Cyborg Citizen
Brunner-Routledge 2001

Greene, Rachel
Internet Art
Thames & Hudson 2004

Igoe, Tom
Physical Computing
Thomson Course Technology 2004

Iovine, John
Robots, Androids, and Animatrons
McGraw-Hill 1997

Johnson, Steven
Emergence: The Connected Lives of Ants, Brains,
Cities, and Software
Simon & Schuster 2001

Keiner, Marion
Manfred Mohr
Wilhelm-Hack-Museum 1994

Koestler, Arthur
The Act of Creation
MacMillan 1963

Lippard, Lucy
Six Years: The Dematerialization of the
Art Object from 1966 to 1972
Praeger 1973

Lovejoy, Margot
Digital Currents
Routledge 2004

Maeda, John
Creative Code: Aesthetics + Computation
Thames & Hudson 2004

Maeda, John
Maeda@media
Rizzoli International Publications 2000

Manovich, Lev
The Language of New Media
MIT Press 2001

Marsh, Tim
'Vicarious Experience in Gaming as Culture' in Essays On Reality,
Identity and Experience in Fantasy Games
(J Patrick Williams, Sean Q Hendricks and W Keith Winkler eds.)
McFarland 2006

McLuhan, Marshall
Understanding Media: The Extensions of Man
Routledge 1964

Merleau-Ponty, Maurice
Phenomenology, Language and Sociology
Heinemann 1974

Minsky, Marvin
Perceptrons
MIT Press 1969 (Reprinted 1988)

Morris, William
William Morris By Himself
Little Brown and Company 1994

Mumford, Lewis
Art and Technics
Columbia University Press 1952

Mumford, Lewis
Technics and Civilization
Columbia University Press 1934

Murray, Janet
Hamlet on the Holodeck: The Future of Narrative in Cyberspace
MIT Press 1998

Negroponte, Nicholas
Being Digital
Vintage 1996

Papert, Seymour
Mindstorms
Basic Books 1980

Pask, Gordon, and Curran, Susan
Microman
Century 1982

Paul, Christiane
Digital Art
Thames & Hudson 2003

Perec, Georges (ed. and trans. by John Sturrock)
Species of Spaces and Other Pieces
Penguin 1997

Purves, Dale, and Beau Lotto, R
Why We See What We Do
Sinauer 2003

Reichardt, Jasia (ed)
Cybernetic Serendipity, the Computer and the Arts
Studio International Special 1968

Reichardt, Jasia
The Computer in Art
Studio Vista 1971

Rhodes, Peter, and Fincham, Robin
Principles of Organizational Behaviour
Oxford University Press 2004

Rosenberg, MJ
The Cybernetics of Art
Gordon & Breach Science 1983

Rush, Michael
New Media in Art
Thames & Hudson 2005

Ryan, Marie-Laure
Narrative as Virtual Reality: Immersion and Interactivity in Literature
and Electronic Media
Johns Hopkins University Press 2000

Stallabrass, Julian
Internet Art: The Online Clash of Culture and Commerce
Tate Publishing 2003

Turkle, Sherry
The Second Self
MIT Press 2005

Virilio, Paul, and Rose, Julie
Open Sky
Verso 1997

Virilio, Paul, and Lotringer, Sylvere
The Accident of Art
Semiotext 2003

Virilio, Paul
The Information Bomb
Verso 2000

Vishmidt, Marina (ed.)
Media Mutandis: a NODE.London Reader
NODE.London 2006

Walker, James Faure
Painting the Digital River
Thames & Hudson 2006

Walter, Shane D., and Hanson, Matt
Motion Blur: OnedotZero – Graphic Moving Imagemakers
Laurence King 2004

Wands, Bruce
Art of the Digital Age
Thames & Hudson 2006

Wands, Bruce
Digital Creativity
John Wiley & Sons 2002

Wardrip-Fruin, Noah, and Harrigan, Pat
First Person: New Media as Story, Performance, and Game
MIT Press 2003

Weizenbaum, Joseph
Computer Power and Human Reason
WH Freeman 1984

White, Michele
The Body and the Screen: Theories of Internet Spectatorship
MIT Press 2006

Wiener, Norbert
Cybernetics
MIT Press 1948

Wilson, Stephen
Information Arts: Intersections of Art, Science and Technology
MIT Press 2002

Zeki, Semir
A Vision of the Brain
Blackwell 1993

Magazines

a-n magazine
www.a-n.co.uk/cgi-bin/db2www.exe/home.d2w/input

Computer Arts
www.computerarts.co.uk

Dazed and Confused
www.dazeddigital.com

Digit
www.thinkdigit.com

**Leonardo Journal of International Society
for the Arts, Sciences & Technology**
www.mitpress.mit.edu/e-journals/Leonardo

MAKE
www.makezine.com/blog/archive/2005/04/google_map_proj.html

Mute
www.metamute.org

Wallpaper
www.wallpaper.com

Wired
www.wired.com

Artists and Projects

Seth Beer	www.graphicalmess.com
Black Shoals / Stock Market Planetarium	www.blackshoals.net
David Blair / Waxweb	www.waxweb.org
Blast Theory	www.blasttheory.co.uk
Paul Brown	www.paul-brown.com
Ed Burton	www.sodaplay.com
Jim Campbell	www.jimcampbell.tv
Kevin Carter	www.co-lab.org/commissions/oral_tradition.html
Michael Chang	www.users.design.ucla.edu/~mflux
Susan Collins	www.susan-collins.net
Nic Collins	www.nicolascollins.com
Richard Colson	www.kwomodo.com
Tom Corby and Gavin Baily	www.reconnoitre.net
James Coupe	www.washington.edu/dxarts/profile_home.php?who=coupe
Paul B Davis	www.beigerecords.com
Andy Deck	www.artcontext.net
Drawbots	www.cogs.susx.ac.uk/ccnr/research/creativity.html
James Faure Walker	www.dam.org/faure-walker/index.htm
Limor Fried	www.ladyada.net/make/x0xb0x/index.html
Gijs Gieskes	www.gieskes.nl
Michel Gondry	www.michelgondry.com
GORI.Node Garden	www.gorigardeners.net/two.php
Mark Hansen and Ben Rubin	www.earstudio.com/projects/listeningPost.html
Ellie Harrison	www.ellieharrison.com
IGLOO	www.igloo.org.uk
Jodi	www.jodi.org
Tom Igoe	www.tigoe.net/pcomp
Edward Ihnatowicz	www.senster.com/ihnatowicz

Daniel Kupfer	www.danielkupfer.com
William Latham	www.doc.gold.ac.uk/~mas01whl
Golan Levin	www.flong.com
Lev Manovich / Soft Cinema	www.manovich.net/softcinemadomain/index.htm
Alex McLean	www.yaxu.org
Agnes Meyer-Brandis	www.ffur.de
Ted Nelson / Xanadu Project	www.xanadu.com
Chris O'Shea	www.pixelsumo.com
The Phone Book	www.the-phone-book.com
Paul Prudence	www.dataisnature.com
Dale Purves and R Beau Lotto	www.purveslab.net/seeforyourself
Markus Quarta	www.somethingonline.org
Brian Reffin Smith	www.krammig-pepper.com/Smith_Ausst.htm
Daniel Rozin	www.smoothware.com/danny
Electrolux Screenfridge	www.electrolux.se/screenfridge
Paul Sermon	www.paulsermon.org
Daniel Shiffman	www.shiffman.net
Sloth-bot	www.arch-os.com/projects/slothbots.html
SoftwareArt	www.runme.org
Squid Soup	www.squidsoup.com
Stanza	www.stanza.co.uk
Stelarc	www.stelarc.va.com.au
Dr John Tchalenko	www.howdoyoulook.co.uk
Jon Thomson and Alison Craighead	www.thomson-craighead.net
Tonic Train	www.mobile-radio.net
Google Will Eat Itself	www.Ubermorgen.com
Woody and Steina Vasulka	www.vasulka.org
Wakamaru Robot	www.mhi.co.jp/kobe/wakamaru/english
Robin Whittle	www.firstpr.com.au/rwi/dfish

Hardware

Arduino USB board	www.arduino.cc
BX-24 Micro controller	www.netmedia.com
PIC chip	www.technobots.co.uk
Lantronix Communication technologies	www.lantronix.com
Tini Micro controllers	www.maxim-ic.com/products/microcontrollers/tini

Software

Eyesweb	www.eyesweb.org
Max/Msp Jitter	www.cycling74.com
Processing	www.processing.org
Pure Data	www.puredata.info

Educational Institutions

Banff Centre, New Media Institute, Canada	www.banffcentre.ca/bnmi/
IAMAS, Tokyo	www.iamas.ac.jp/
Lansdown Centre for Electronic Art, Middlesex University	www.cea.mdx.ac.uk/
IDAT @ Plymouth University	www.i-dat.org/go/home
Ravensbourne College of Design and Communication	www.ma.rave.ac.uk
Professor Warwick @ University of Reading	www.cyber.reading.ac.uk/people/K.Warwick.htm
Royal College of Art	www.interaction.rca.ac.uk/
School of Visual Arts, New York	www.sva.edu/
TISCH ITP, New York	www.itp.nyu.edu/itp/flash/Home
Thames Valley University	http://mercury.tvu.ac.uk/da
Institute of Neurology, Wellcome Department of Imaging Neuroscience, University College, London	www.fil.ion.ucl.ac.uk/

Discussion Forums

Bruce Sterling's Weblog	www.blog.wired.com/sterling
Computer Arts Society	www.computer-arts-society.org
CRUMB	www.newmedia.sunderland.ac.uk/crumb/phase3/index.html
Cybersalon	www.cybersalon.org
Digital Arts Network	www.digitalartsforum.org.uk/forum/index.php
Joichi Ito's Weblog	www.joi.ito.com
Takeaway Festival of Do-It-Yourself Media	www.takeawayfestival.com
we-make-money-not-art	www.we-make-money-not-art.com

Exhibitions and Museums

Art and Money Online	www.tate.org.uk/britain/exhibitions/artnow/art_and_money_online/default.shtm
Arts in Action	www.artsinaction.net
Artsadmin	www.artsadmin.co.uk/
Artsway	www.artsway.org.uk/
Baltic	www.balticmill.com/
Bryce Wolkowitz Gallery	www.brycewolkowitz.com/
Digital Art Museum [DAM] Berlin	www.dam.org/
DRU (Digital Research Unit), Huddersfield	www.druh.co.uk/
Event Network, London	www.eventnetwork.org.uk/
Eyebeam Openlab New York	www.research.eyebeam.org/
FACT, Liverpool	www.fact.co.uk/
Film and Video Umbrella	www.fvumbrella.com/
FurtherAfield	www.furtherfield.org/
Futuresonic	www.futuresonic.com/
HTTP Gallery	www.http.uk.net/
ICC Tokyo	www.ntticc.or.jp/index_e.html
KINETICA	www.kinetica-museum.org/
LoveBytes Digital Art Festival	www.lovebytes.org.uk/
New York Digital Salon	www.nydigitalsalon.org/
NODE	www.nodel.org
Nunnery Gallery	www.bowarts.org/thenunnery/index.php?code=41
OFFF	www.offf.ws/
Postmasters Gallery	www.postmastersart.com/
Prix Ars Electronica	www.aec.at/en/
Q Arts, Derby	www.q-arts.co.uk/parseTemplate.asp
Rhizome.org	www.rhizome.org/
SCAN	www.scansite.org/?w=996&h=422
Transmediale	www.transmediale.de/site/
Watermans	www.watermans.org.uk/
ZKM, Karlsruhe Center for Art and Media	www.on1.zkm.de/zkm/e/

Glossary of terms

8-bit 16-bit 32-bit
Descriptions of the amounts of data in a sound or an image file

ADC
Acronym for an analogue to digital converter

Analogue
A way of representing one type of information with another

Array
Memory structure for storing ordered data on a computer is usually in the form of an array

ASCII
American Standard Code for Information Interchange - the standard ASCII character set consists of 128 decimal numbers ranging from zero through 127 assigned to letters, numbers, punctuation marks, and the most common special characters

Binary Values
Computers require information to be presented in binary format and this means supplying it as a series of 1s or 0s

Bisociation
Two completely separate areas of experience mapped onto one another

Blog
Shortened form of Weblog. An online diary including images and text that also allows readers to post comments in response to items

Bluetooth
Bluetooth technology is how mobile phones, computers, and personal digital assistants (PDAs), not to mention a broad selection of other devices, can be easily interconnected using a short-range wireless connection

Circuit-bending
A practice that generally means a creative application of short circuits to electronic devices

Class
A key component of object-oriented programming. The class is a template or a method used to create independent instances of itself

Cognitive neuroscience
The study of the human brain

Creative commons
Alternative scheme to copyright for the protection of intellectual property

Cybernetics
A science of control and communication in complex electronic machines and the human nervous system

Cyborg
Any artificial system connected through reciprocal feedback to an organism (Jack Burnham)

Flickr
A facility for uploading and sharing images on the Web

GIS (Geographical Information System)
A positioning system based on location of key landmarks as opposed to satellites

GPS (Global Positioning System)
Used for determining location and based on a position relative to three different satellites

Haptic
Relating to the sense of touch

Hypertext
Method of linking text with additional content used within an Internet browsing environment

Image Metadata
Embedded descriptions of an image; these are normally unseen

Instance
A term used in object-oriented programming: an individual item that has been created by a call to a class

IP
Internet Protocol: providing the fragmentation, routing and reassembly of data that is the basis of online communication

LED
Light emitting diode

Micro controller
A computer-on-a-chip used to control electronic devices. It is a type of microprocessor emphasising self-sufficiency and cost-effectiveness.

MRI scan
Magnetic Resonance Imaging

MYSQL
A piece of software for describing databases. MYSQL has an instruction set for writing and retrieving data. The data is accessible across all platforms

Object
A term used in object-oriented programming, an independent entity or individual item created from a class

Object-oriented programming
A modular, threaded, recyclable and flexible programming method

Open Source
An approach to software development that is based on not-for-profit sharing. It is important that those who use such software provide details and credit the authors in any work that they publish

PET scan
Positron Emission Tomography

PHP
Hypertext Preprocessor: a server side language that is invisible to the viewer but adds functionality to a web page

PIR
Passive Infra Red sensor

Pixels
Picture elements

Potentiometers
Variable resistors in an electronics circuit that are controlled by turning or sliding. An example would be a volume control

Primary visual cortex
The area of the brain that has been identified as dealing with visual stimuli and signals received from the optic nerve

Protocol
A standard way of communicating across a network. A protocol is the 'language' of the network. A method by which two dissimilar systems can communicate

Real-time
Immediate moment by moment update of information

RGB
A computer colour model to describe images

Saccades
Quick, simultaneous movements of both eyes in the same direction

Tags
Word or phrase attached to an image as part its metadata

Telematics
The use of a computer network to allow users in different locations to share aspects of their experience. This normally occurs in real-time

Ultrasonic sensors
They emit a sound that is not audible to the human ear and can pick up its echo. It is the time difference between these two that is used by a program as a way of measuring the distance of an object from the device

Vicarious experience
Experience at one remove

Web 2.0
Used to describe an approach to content on the World Wide Web where the balance has shifted away from the centre. The content is from the user base rather than the authors

WiFi
Wireless network

Index

Acknowledgements

This book has grown out of the experience and knowledge gained as a result of being part of a community that is driven by a desire to share its discoveries and understanding. I have benefited from the expertise of many members of such a community and it would be impossible to refer to them all by name. I have been astonished at the generosity of artists and others who have so willingly made their work available for publication in this book. Without them, it would have been impossible to make the arguments with the kind of force that I have tried to approach. Indeed, the book could not have been completed without their cooperation.

I am very grateful to Alan Schechner at Thames Valley University for relieving me of some of my duties in the Faculty of Arts so that I had a chance of making the copy deadlines! I should also mention Jeremy Gardiner, Ian Grant and Mitja Kostomaj in the Digital Arts department. Paul B Davis gave me great assistance with the section on Reverse engineering. My students of different periods have also featured in different ways in the book and this is greatly appreciated.

Jasia Reichardt very generously loaned me an original copy of the catalogue for Cybernetic Serendipity and made available some wonderful material from the exhibition and associated writing.

Paul Brown was an enthusiastic supporter from the beginning both in the UK and online from Australia.

I would like to thank AVA's Publisher, Brian Morris, and Caroline Walmsley, AVA's Editor-in-Chief, for her patient attention to detail and her unflagging support at all stages of the book's development. Catherine Mason's assistance on the picture research was an important contribution. I would also like to thank Simon Slater for page and cover design.

I received helpful assistance from the staff at the Tate Gallery Research Centre in London.

I also gained much needed insight from comments provided by Tom Igoe at ITP, New York.

I would like to thank Geraint Rees, Professor of Cognitive Neurology at the Institute of Neurology, Wellcome Department of Imaging Neuroscience, University College, London. He provided assistance with my research relating to human vision.

Thanks are also due to Electrolux, Xlproductions, Shane Walter at OnedotZero, Prix Ars Electronica, Rene Block, John Marshall and ITN News Ltd.

I also mention here: Susumu Asano, Gavin Baily, Richard Barbrook, Seth Beer, Lukas Birk, Ilze Black, Stephen Boyd-Davis, Paul Brown, Danny Brown, Ed Burton, Jim Campbell, Susan Collins, Beryl Graham and all at CRUMB, Tom Corby, James Coupe, Gordon Davies, Andy Deck, James Faure Walker, Charlie Gere, Rupert Griffiths, Professor Karel Dudesek, Ken Ko, Daniel Kupfer, William Latham, Wolfgang Leiser, Golan Levin, Alex Mclean, Agnes Meyer-Brandis, Magnus Moar, Chris O'Shea, Richard Oliver, Brad Paley, Dave Patten, Mike Phillips, Paul Prudence, Markus Quarta, Hannah Redler, Hedley Roberts, Daniel Rozin, Paul Sermon, Daniel Shiffman, Stanza, Stelarc, Lewis Sykes and Keith Watson.

My wife Suzette has supported me tirelessly throughout this project and acted as a sounding board when my ideas proved reluctant to form themselves. I cannot thank her enough for her patience. I would also like to thank my sons Max, Conrad and Ivor for their understanding and encouragement.

All reasonable attempts have been made to trace, clear and credit the copyright holders of images reproduced in this book. However, if any credits have been inadvertently omitted, the publisher will endeavour to incorporate amendments in future editions.

WITHDRAWN

186315